Revealing Selves

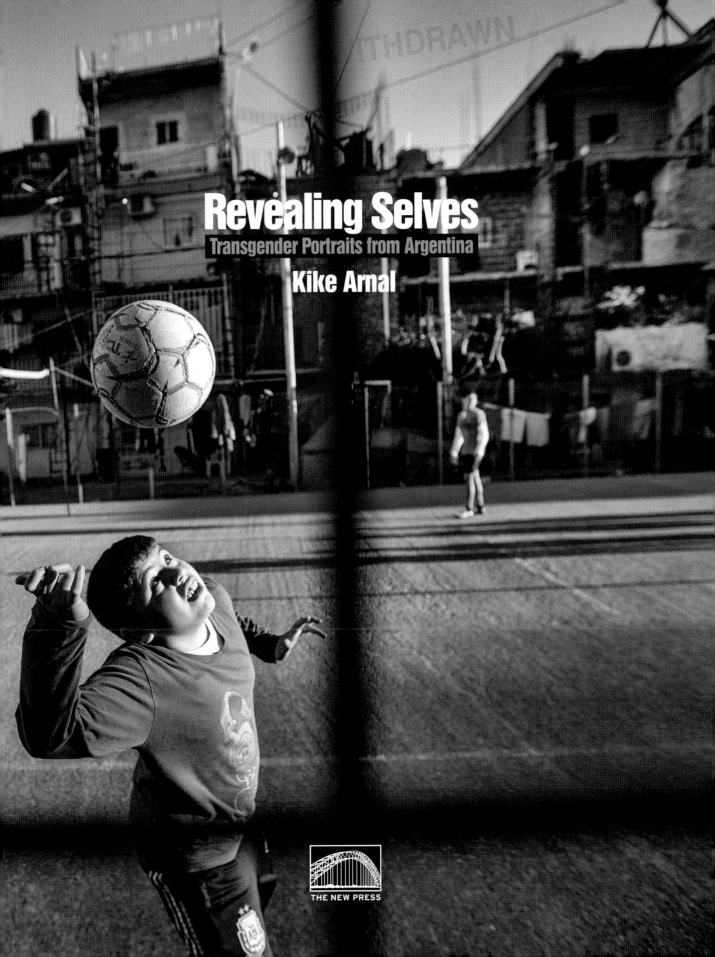

Revealing Selves
Transgender Portraits from Argentina

Kike Arnal

THE NEW PRESS

© 2018 by Kike Arnal
Preface © 2018 by Jon Stryker
Introduction © 2018 by Josefina Fernandez
All rights reserved.
No part of this book may be reproduced, in any form, without written permission from the publisher.

Requests for permission to reproduce selections from this book should be mailed to:
Permissions Department, The New Press, 120 Wall Street, 31st floor, New York, NY 10005.

Published in the United States by The New Press, New York, 2018
Distributed by Two Rivers Distribution

ISBN 978-1-62097-287-8 (pbk)
ISBN 978-1-62097-288-5 (e-book)
CIP data is available

The New Press publishes books that promote and enrich public discussion and understanding of
the issues vital to our democracy and to a more equitable world. These books are made possible
by the enthusiasm of our readers; the support of a committed group of donors, large and small;
the collaboration of our many partners in the independent media and the not-for-profit sector;
booksellers, who often hand-sell New Press books; librarians; and above all by our authors.

www.thenewpress.com

Book design and composition © 2018 by Emerson, Wajdowicz Studios (EWS)
This book was set in Franklin Gothic, Helvetica Inserat, Helvetica Neue, News Gothic, and Meta Pro

Printed in the United States of America

10 9 8 7 6 5 4 3 2 1

Preface
JON STRYKER

The project was born out of conversations that I had with Jurek Wajdowicz. He is an accomplished art photographer and frequent collaborator of mine, and I am a lover of and collector of photography. I owe a great debt to Jurek and his design partner, Lisa LaRochelle, in bringing this book series to life.

Both Jurek and I have been extremely active in social justice causes—I as an activist and philanthropist and he as a creative collaborator with some of the household names in social change. Together we set out with an ambitious goal to explore and illuminate the most intimate and personal dimensions of self, still too often treated as taboo: sexual orientation and gender identity and expression. These books continue to reveal the amazing multiplicity in these core aspects of our being, played out against a vast array of distinct and varied cultures and customs from around the world.

Photography is a powerful medium for communication that can transform our understanding and awareness of the world we live in. We believe the photographs in this series will forever alter our perceptions of the arbitrary boundaries that we draw between others and ourselves and, at the same time, delight us with the broad spectrum of possibility for how we live our lives and love one another.

We are honored to have Kike Arnal as a collaborator in *Revealing Selves.* He, and the other photographers in this ongoing series, are more than craftspeople: they are communicators, translators, and facilitators of the kind of exchange that we hope will eventually allow all the world's people to live in greater harmony. ■

Jon Stryker, philanthropist, architect, and photography devotee, is the founder and board president of the Arcus Foundation, a global foundation promoting respect for diversity among peoples and in nature.

Introduction
JOSEFINA FERNANDEZ

Why, we might wonder, would a collection of photographs of trans people be titled *Revealing Selves?* To reveal means to discover or express what is unknown or secret, to provide evidence or certainty about something. What secrets do Arnal's photographs reveal? What do they show us about their subjects? What about them is secret or unknown? Why do these people feel obligated to tell us, "This is who we are"?

For a long time, trans people have been denied the right to their own name and identity. They have been prevented from expressing themselves as they are. This has driven a struggle that, with varying levels of intensity, continues in Argentina to this day.

A name is a means by which we lay claim to how we want others to recognize us—not only in Western cultures, but in other cultures, too. For instance, the Japanese artist Hokusai changed his name thirty times, one for each year of his life; it was how he celebrated his birthday. The Nanai people, from the border region between China and Russia, change their children's names as many times as necessary until they are happy. There are a few cultures, including the Dayak of southern and western Borneo and the Haida of Haida Gwaii (formerly the Queen Charlotte Islands) in British Columbia, in which relatives' names are changed when they are sick, or after they are cured, in order to trick whatever is responsible. The Guarani of Paraguay, southern Brazil, and the Argentine coast must change names when they commit any kind of moral infraction. The list goes on.

In Western societies, we are assigned a name that, more often than not, identifies us as either female or male based on a set of anatomical signifiers at birth, most fundamentally the genitalia. As we mature, we usually adhere to conventions that parcel out attributes such as dress, accessories, gestures, and behavior to one of the two recognized genders. After all, as Judith Butler demonstrated, for gender identities to be intelligible, the genders must maintain a certain degree of coherence and contiguity with our sexed bodies.[1] This usually goes unnoticed by those who are born female and become women and those who are born male and become men. But the same cannot be said for those who walk a path in contradiction to the gender they were assigned at birth.

In Argentina's earliest medical records, from the late nineteenth and early twentieth centuries, trans people were listed under the term *invertidos sexuales.* They were portrayed as deviants, degenerates, sexual aberrations, mentally impaired individuals who had lost control of their passions, who had been severed from the moral conscience of society and therefore deserved to be confined in medical-psychiatric institutions or under police supervision. They were accused of spreading "maladies of the spirit" and undermining the morality of the new nation. Doctors' offices and jail cells were the preferred ways of treating these people.

This perspective remained largely in place for many years. Decades passed before the trans movement's demands were heard, and it was not until the early twenty-first century that gender identity in Argentina achieved greater institutional recognition. Local trans activism was critical to this success. This country has been fortunate enough to have incredible trans leaders, who in scarcely a decade enacted an agenda that, in the early nineties, would have seemed beyond the realms of possibility. This is, in part, thanks to the inspiration of a golden generation of human rights

[1] Judith Butler, *Gender Trouble: Feminism and the Subversion of Identity* (New York: Routledge, 1990).

activists, of the Mothers and Grandmothers of the Plaza de Mayo, of the children of those who were arrested and disappeared, and many others. Trans activists knew that they had to live up to that tradition.

The trans movement's first major undertaking was the repeal of the Buenos Aires police edicts. From the middle of the twentieth century, federal and local police had been given the authority to suppress offenses not specified in the penal code. Flouting the constitution, the police used these edicts against acts known as *figuras contravencionales,* two of which directly affected trans people: publicly exhibiting oneself in clothing of the opposite sex, and soliciting for sex in a public place. Trans people could be imprisoned for up to twenty days if found guilty of either offense. The fight to have these acts removed from the *figuras contravencionales* took place mainly from 1996 to 1998, and it marked an opportunity for the trans movement to begin organizing independently of other, mostly gay, activist groups, in which they had been included to a limited degree. Trans activists worked to raise awareness of their living conditions and to have those conditions recognized as a violation of their most basic human rights.

It took four years for the state to recognize the Asociación de Lucha por la Identidad Travesti y Transexual (Association for the Struggle of Transvestite and Transexual Identity) as a legal entity. The case made it to the Supreme Court, which, in 2007, ruled in favor of the organization. The verdict had an international impact. It was the first time that the highest court of any state in the world had recognized the extreme vulnerability of trans people and the problems that can arise when judges wash their hands of the interests and grievances of minority groups. This act was just the tip of the spear for later victories.

Queer activism continued to shake up Argentina's legal and bureaucratic landscape. In 2010, a law was passed that gave equal rights to all married couples, regardless of their sex. This expansion of marriage law created families that demanded further changes, such as the modification of adoption laws and adjustment of kinship rights associated with the use of new assisted-procreation technologies. And if these changes came as a surprise to many people in Argentina, what did they make of the Gender Identity Law in 2012?

The passage of this law entailed a paradigm shift over how gender identities are perceived in Argentina, moving from a model that pathologized and criminalized gender nonconformity to a model based on self-determination and respect for human rights. The law enshrines the right to correct information in the public register when it does not match an individual's self-perceived gender, and it guarantees comprehensive access to free health care that includes hormones and total or partial sexual-reassignment surgery. Full enjoyment of these rights does not require a medical or psychological diagnosis, nor does it require the sanction of scientific or bioethical committees. Furthermore, unlike legislation elsewhere in the world that requires individuals to be sterilized in order to change gender, this law preserves reproductive and other rights. Any action that obstructs, denies, or otherwise harms any of the rights guaranteed by the law is deemed discriminatory. In short, the Gender Identity Law is both an ideological break and a landmark exercise of citizenship by trans rights groups.

What we find in Arnal's book are first and foremost images of people at work, in love, with their families, and in their communities. Arnal does not take the easy route so often followed by those who approach the trans world, recording

images of idealized femininity or elaborate artifice. He illuminates the hidden experiences, conveying them in an intimate, familiar way. He gives the people in these photographs their humanity and frees them from their assigned places in society.

We meet Cinthia, a trans woman from Salta Province, who, like so many other trans women, went to Buenos Aires seeking the anonymity that was impossible in the small town where she was born, where she was the "shame" of her family. Cinthia was imprisoned for more than five years for wearing women's clothes and for soliciting on the street. Every two months, and sometimes more frequently, she was detained by the police and imprisoned for twenty days—adding up to five years in prison simply for exercising her right to her own identity, for showing herself as she is, for revealing herself, for rebelling. When she was nearly fifty years old, with the encouragement of her daughters, she finished her schooling. Even though a high school diploma is obligatory in Argentina, around 60 percent of trans women do not make it that far. Expelled from the family home at an early age, rejected at school, and struggling to survive, most drop out.[2]

We also see photographs of El Gondolín, a building that was once a hotel and is now home to a community of trans women who have not received any housing assistance from the state. El Gondolín is located in the Palermo neighborhood, known as Palermo Soho for its high-end shopping and luxury real estate. El Gondolín houses between thirty and fifty trans women, on average

no older than thirty, who, like Cinthia, came from inland Argentina lacking the income necessary to rent a hotel room or a private residence. Of Buenos Aires's trans women, 65 percent live in hotel rooms or have rooms in occupied houses.[3] There are several reasons for this: the mere fact of being trans drives up rent, and it is virtually impossible for these women to meet the requirements set by the housing sector to sign a rental contract. Because they do not have a steady source of employment, they do not have pay stubs to verify their economic stability, and because they rarely have close acquaintances, they do not have personal references. Living conditions can be truly dismal, and residences are often overcrowded. Against this backdrop, El Gondolín welcomes young trans women and provides them with protection and care.

There is one photo in this collection I'd like to pause on for a moment: it is the one where Florencia and her companions are gracefully descending the subway stairs. I have been connected to the trans community for more than twenty-five years, and when I saw that photo, I remembered one of our earliest political actions: using public transportation. To avoid mockery and derision on the street, trans women would only move through the city in taxis, a private means of transport that provided protection and guarded against the public's gaze. Turning to public transit was one of the trans movement's first steps to exercise its rights.

"If someone were to ever love me, I'd want him to say, without any sort of prejudice, 'My partner is a trans woman.' With all of my soul, I would want that revolutionary to be able to feel and shout to the four winds, 'I love a trans woman.'"[4] This was the wish of one of the leading activists in Argentina's LGBTQ movement, Lohana Berkins, who passed away in February

[2] This information comes from research I coordinated as the director of the Gender and Sexual Diversity Program at the Public Defender's Office of Buenos Aires, which was published as *La Revolución de las Mariposas: A diez años de La Gesta del Nombre Propio* (Buenos Aires: MPD, 2017).
[3] Ibid.
[4] C. Castelnovo, "Poner el cuerpo," *Espacio Latino* (October 2013).

2016. These could have been the words of any trans woman. If prejudices about gender continue to hinder trans people's access to education, employment, health care, and housing, then love seems even more remote. Kicked out of their homes at a young age, abused by the very people who ought to love them, thrown into the streets to fend for themselves, forced at a young age to trade sex for money—what room is there for love? This is a question for Florencia and Alejandro. She is a self-defined trans woman from greater Buenos Aires, a communist, abolitionist, activist, journalist, and photographer. He is a former combatant in the Falklands War who has experienced hell. They became legally and happily married after the passage of the Gender Identity Law.

We meet Emmanuel, a trans man who works as a tattoo artist. He has had a line tattooed on his neck that merits our attention: *los muchachos no lloran.* Boys don't cry. It is the canonical gender imperative for men, and also the title of a film that shows the terrible cost for men assigned a female gender at birth and socialized as women.[5] Trans men remain underrepresented in academic research, the media, and various spheres of life. In this culture, masculinity, unlike femininity, is relatively nonperformative, and perhaps for this reason it is simpler for trans men to go unnoticed. Perhaps it is a tactic—not necessarily a conscious one—that enables them to weather socially disadvantageous situations?

We also meet Serena, a trans woman who has been working as a volunteer nurse in one of the city's hospitals for ten years but has yet to be recognized as a formal employee. Neither her years as a volunteer nor her recently acquired nursing degree has been enough to counter the prejudices that persist in the labor market. Serena is one of the 88 percent of trans women who have never had a formal job and who face formidable challenges finding even the most precarious work.[6] Ultimately, this means that sex work is the most significant source of income for trans women. Seventy percent of trans women in Buenos Aires, and 90 percent of those between eighteen and twenty-nine, are sex workers. Eighty-seven percent of those women would leave it if they had access to an alternative form of employment.[7]

However progressive legislation may be, it cannot immediately erase the violence and the social, political, economic, structural, and systematic exclusion of trans people in Argentina that is responsible for their extremely low life expectancy: while the national average life span in Argentina is seventy-seven, for trans women, it is thirty-five. For all this, they are revealing themselves, showing themselves in the photographs as they are and demanding recognition. And it is clear that Arnal has won the trust of the people he is photographing. Otherwise, how could he convey, as skillfully as he does, the feeling of what it's like to share a meal with Cinthia's family, to see Serena's empathy for a hospitalized patient, to join a street protest with Florencia, to attend a class with residents of El Gondolín, to rest tenderly on a woman's breasts as Emmanuel does. These images show us the everyday lives of people who, for many years, have been fighting for the right to their own name, to be who they are. ■

[5] The film *Boys Don't Cry* (1999) is an American film directed by Kimberly Peirce, starring Hilary Swank and Chloë Sevigny. It is based on the true story of Brandon Teena, a young trans man who was raped and murdered by his neighbors and friends in Falls City, Nebraska, on December 31, 1993, when they discovered that he had female genitals.
[6] *La Revolución de las Mariposas.*
[7] Ibid.

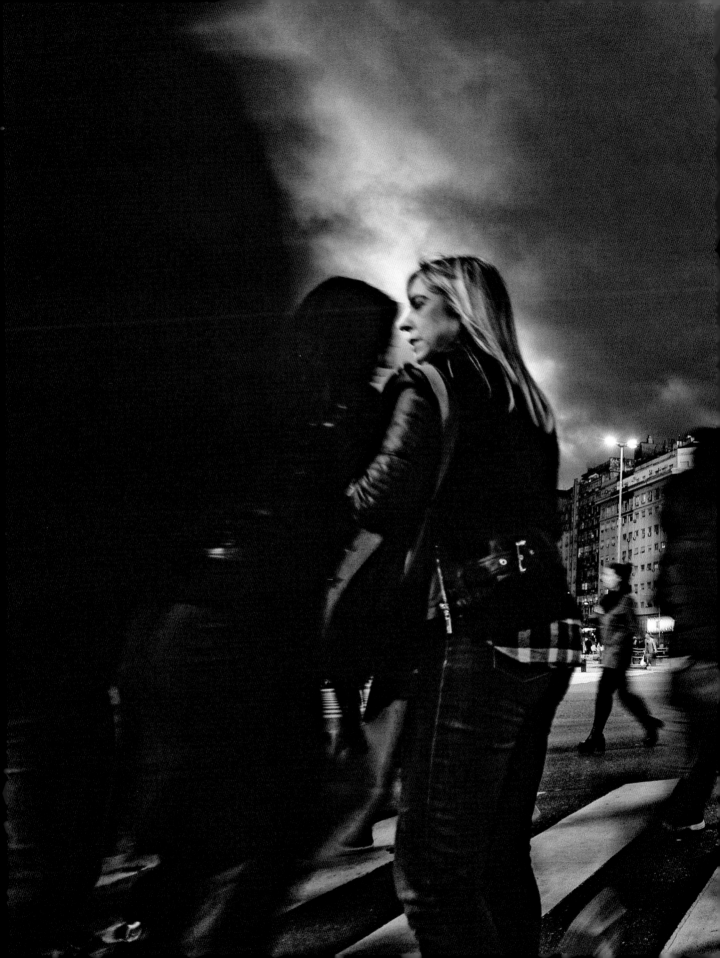

"I want to live, I don't want to be killed in the streets."
—Florencia Güimaraes Garcia

Cinthia
Arroyo

A former sex worker who moved to Buenos Aires, Cinthia is now a librarian and a devoted single mother, working to provide her three daughters with an education and a stable, loving home.

Cinthia Arroyo was born Luis Wilfredo Arroyo in Embarcación, a small city in Salta Province, in northern Argentina. One of five children in a working-class family, she began secretly trying on her mother's clothes when she was only five years old. Her family accepted her gradual transition to become Cinthia, but it was a different story with the community: the city was deeply conservative, and Cinthia suffered terrible abuse and discrimination.

Cinthia left home and began looking for a job in Embarcación, but she couldn't find any work. As her financial situation deteriorated, she became a sex worker. She was only nineteen when she started walking the streets at night. Eventually, Cinthia moved to Buenos Aires with other transgender friends, who, like her, were searching for better opportunities.

One day when Cinthia was partying with a group of transgender friends, she met Cristina Mabel Meaya, a young woman in her teens. It was the

> ## "I wish my transgender friends would understand that sex work is not the only way to earn a living."

beginning of an intense relationship. Initially, Cinthia had felt embarrassed dating a woman who was not transgender. She wondered what her friends would think. But it wasn't long before their first daughter, Amira Ayelen, was born. Then came Nahir Daiana, and then Zamira Naomi.

The relationship between Cinthia and Cristina wasn't easy. Cristina liked to party and she got hooked on drugs, which threatened the stability of their family and home. Desperately looking for support, Cinthia took her three daughters back to her parents' home in Salta, while Cristina stayed behind. Infected with AIDS and homeless, Cristina passed away on January 6, 2013, in the streets of Buenos Aires.

Left alone and out of work, Cinthia faced the challenge of educating her daughters and providing them with a good home. She moved back to Buenos Aires and for a few months worked at a clothing cooperative in Villa 31, the slum where they lived,

but the business failed and the co-op was shut down. Desperate, she took a job working long hours cleaning bathrooms at a hospital. With her daughters, the last thing Cinthia wanted to do was to return to sex work. Eventually, she was employed as an assistant at the central library of the city's Judiciary Power in downtown Buenos Aires. She worked during the day and studied at night to finish high school. In 2016, the Judiciary Power decided to open a library branch named Biblioteca Popular "Padre Mugica" in Villa 31, and Cinthia was appointed as librarian there.

Finally, life was looking brighter for Cinthia and her daughters. But there was still one very important issue to resolve: Cinthia no longer wanted to be her daughters' father; she wanted to be their mother. The legal hurdles, however, proved insurmountable—until the passing of the Gender Identity Law. Finally, Cinthia was able to become what she had wanted the most: the mother of Amira, Nahir, and Zamira.

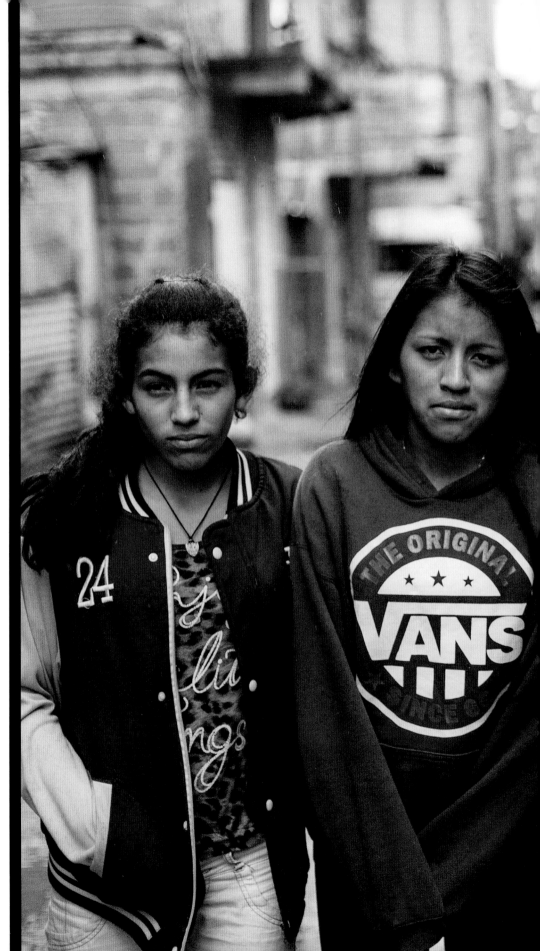

Cinthia and her
three daughters,
Amira Ayelen, Nahir
Daiana, and Zamira
Naomi, in Villa 31,
Buenos Aires.

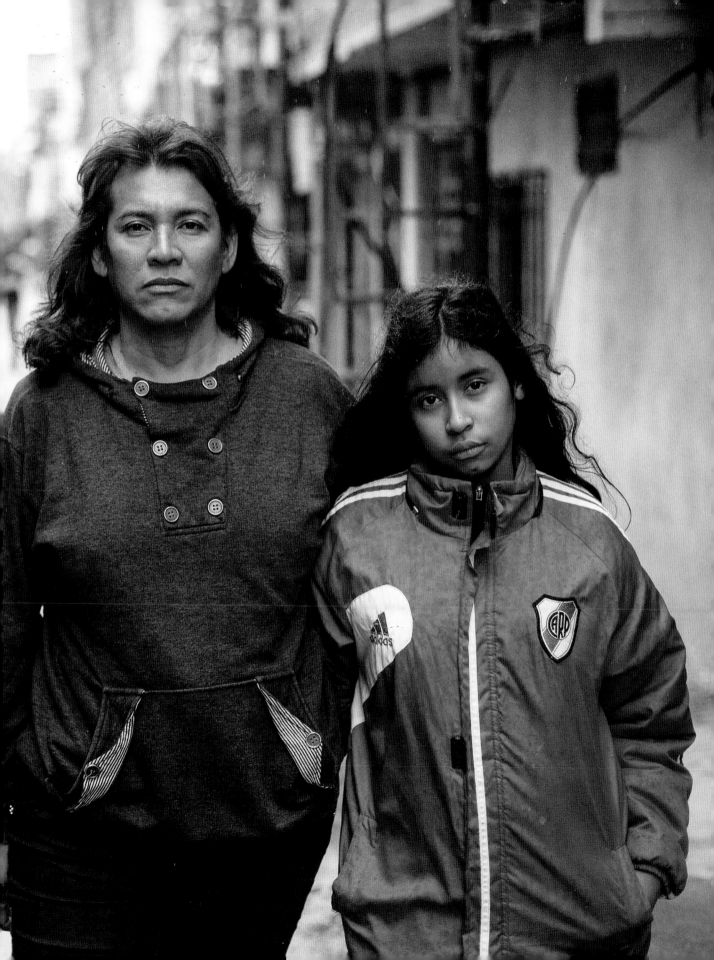

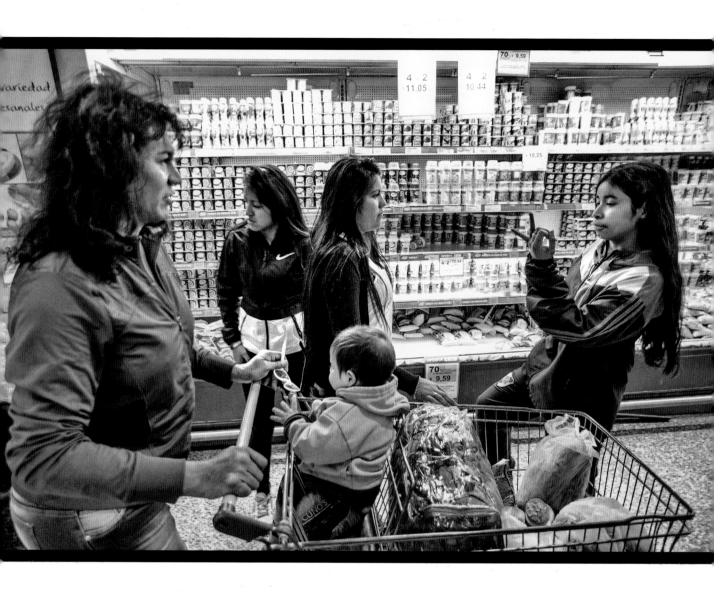

Cinthia and her daughters at the supermarket with her one-year-old nephew Samir.

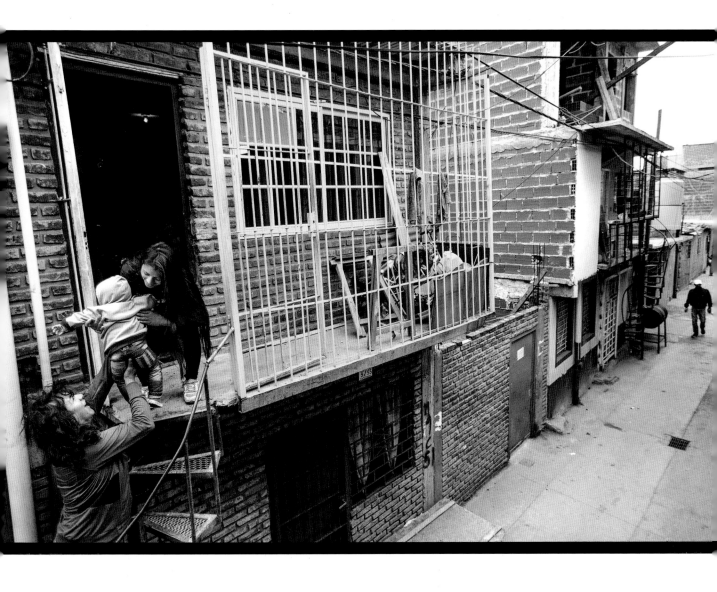

Cinthia passes
Samir to Amira at
the door to their
home in Villa 31.

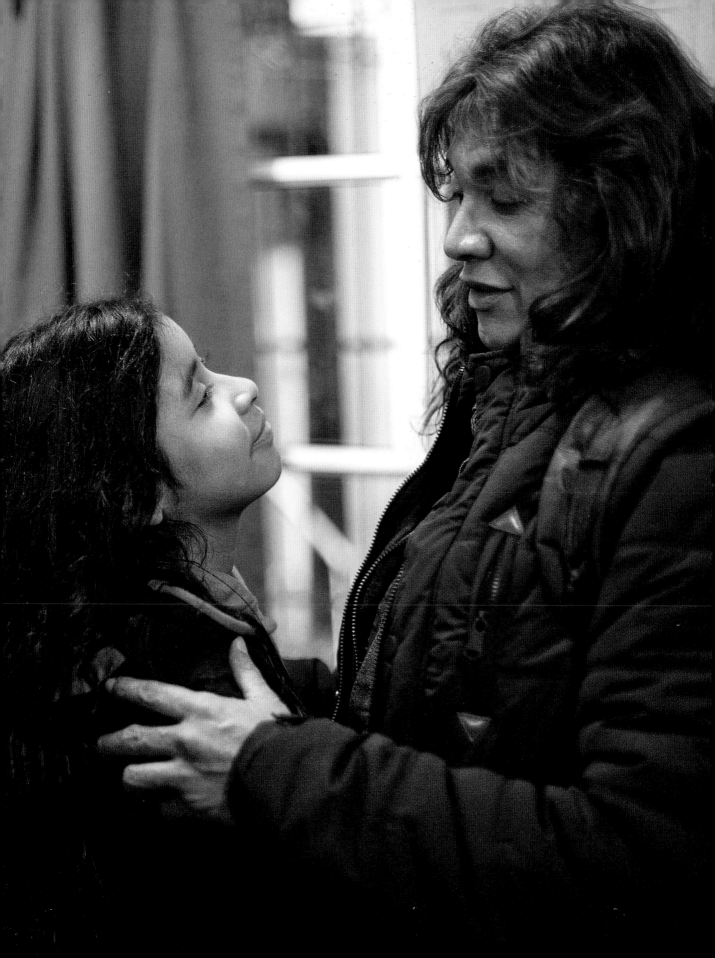

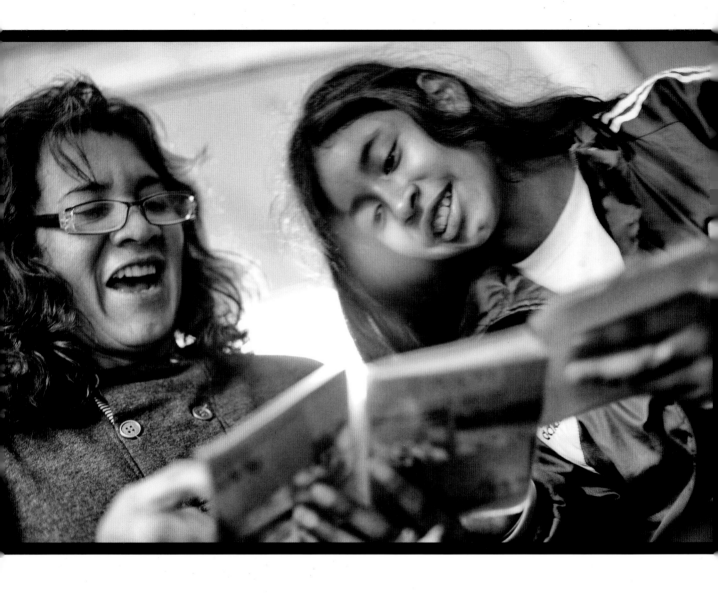

Friends and family
look at old photos
of Cinthia.

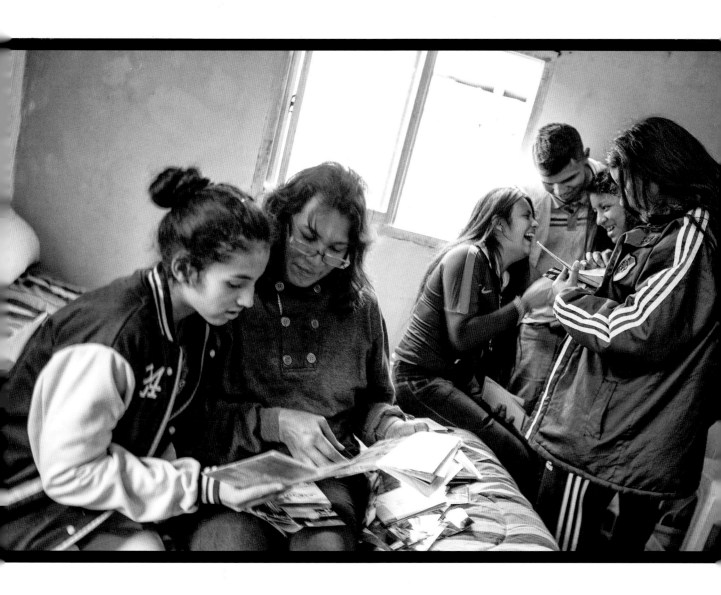

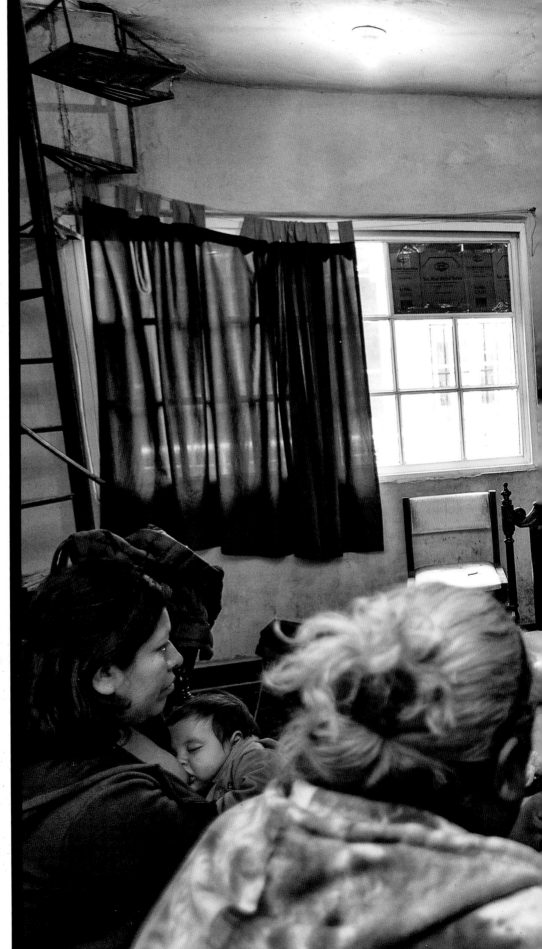

On a Sunday lunch at her home in Villa 31, Cinthia helps her younger daughter Zamira to cut a steak. Cinthia is the gravity center for her family, and even though her resources are very limited, she likes to entertain family and friends, in this case her daughters, her sister, and other relatives from Embarcación.

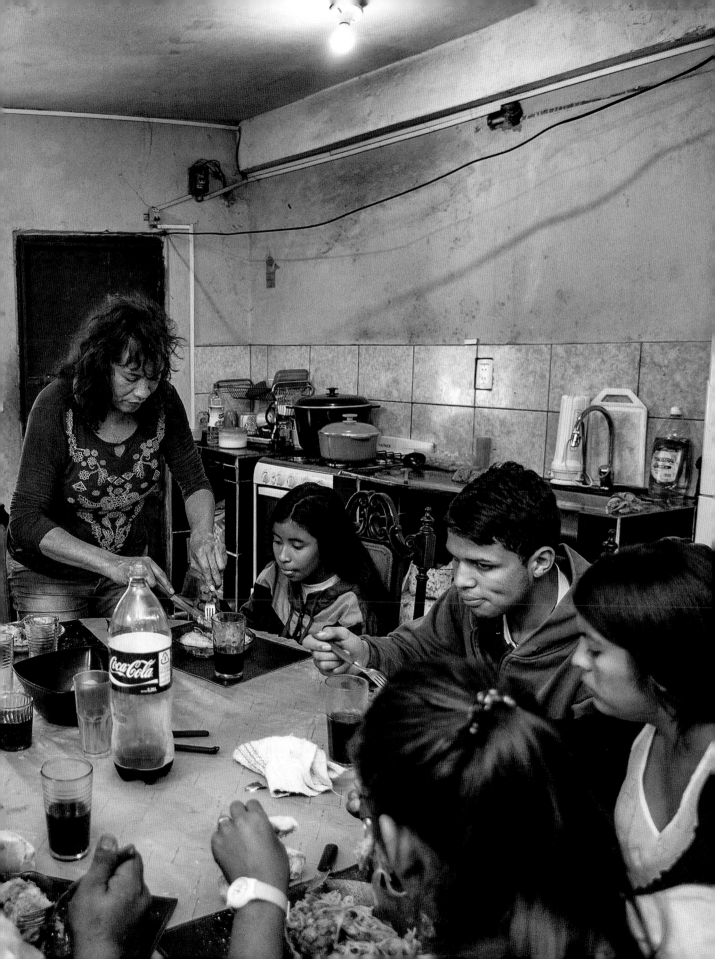

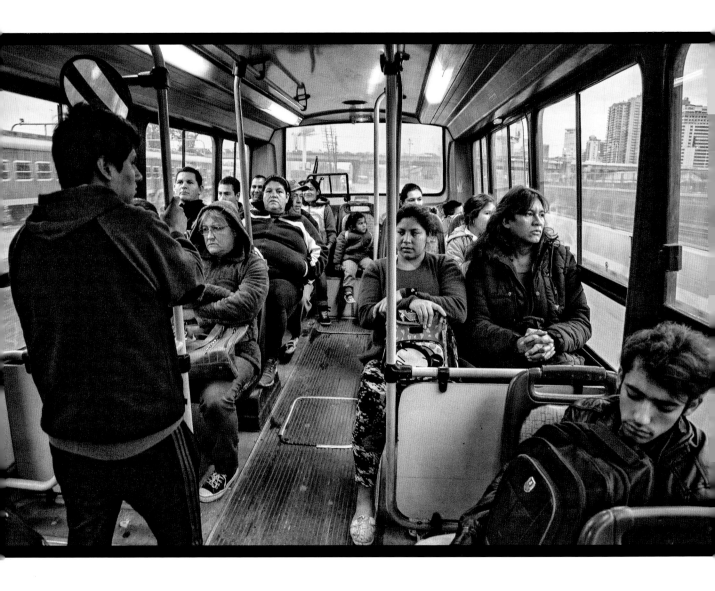

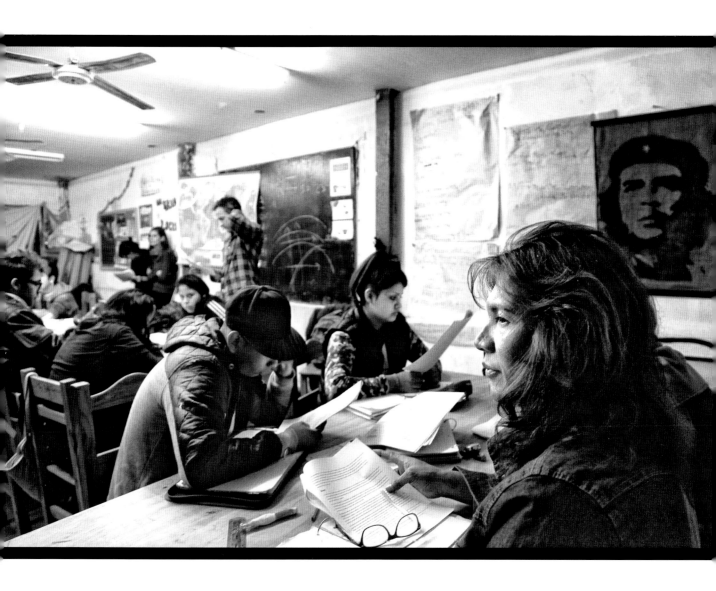

At night, after
finishing her work
at the library and
dropping home to
see her kids, Cinthia
attends classes
to finish her high
school diploma.

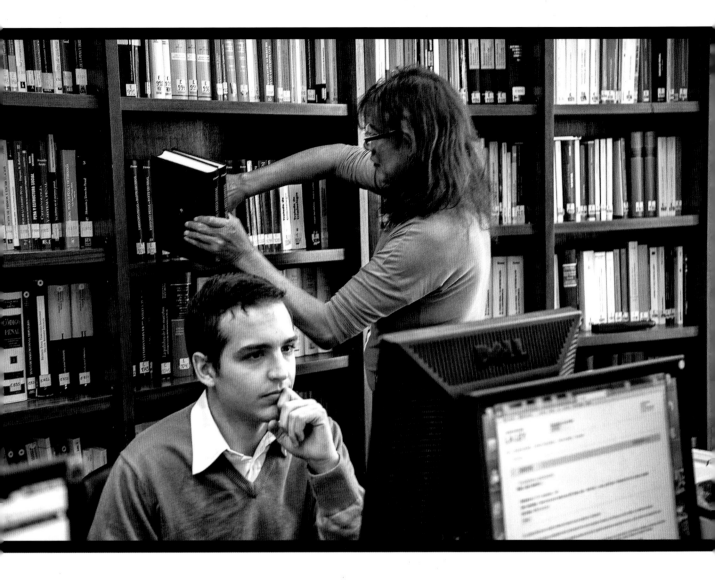

Cinthia working
at the central
library of the
Judiciary Power
in downtown
Buenos Aires.

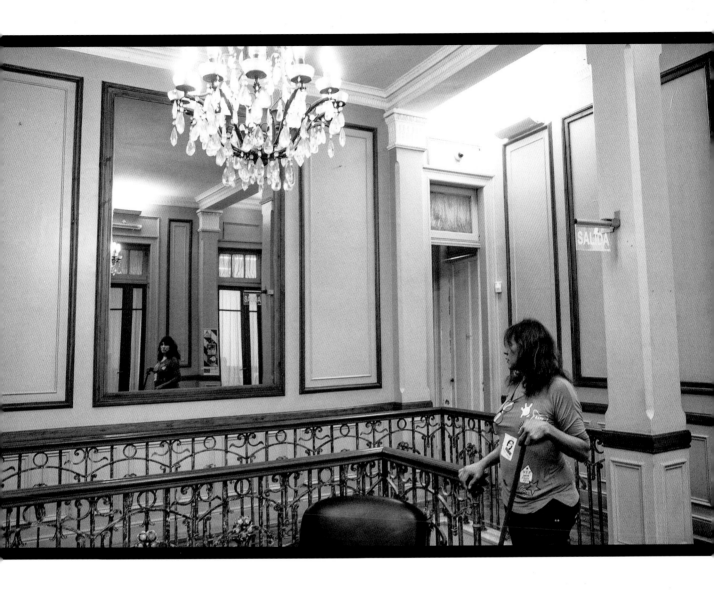

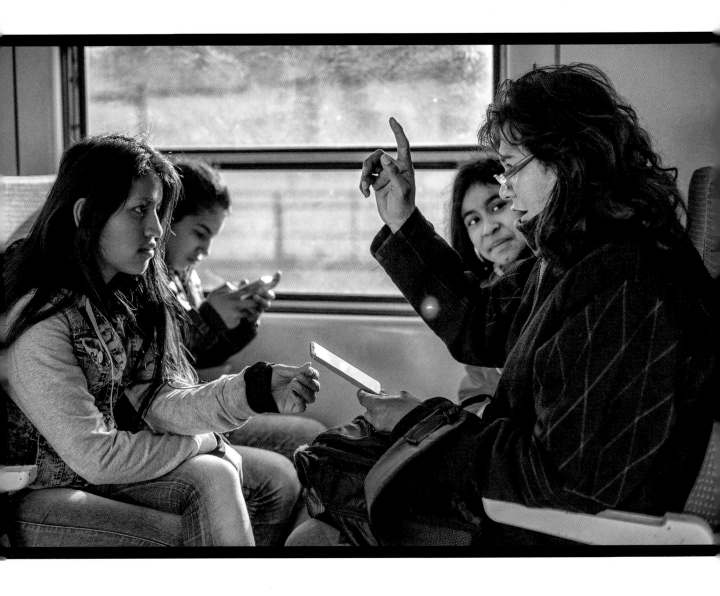

Every month Cinthia
takes her daughters
to visit their mother
at La Chacarita, one
of Buenos Aires's
cemeteries.

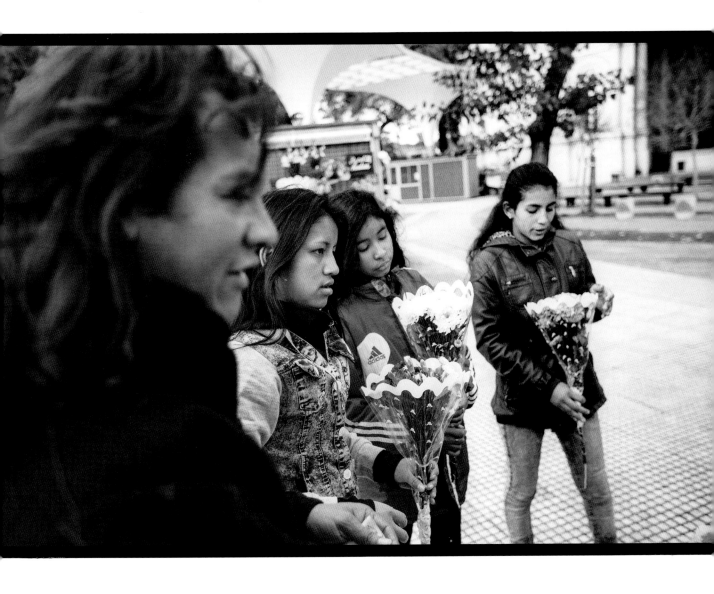

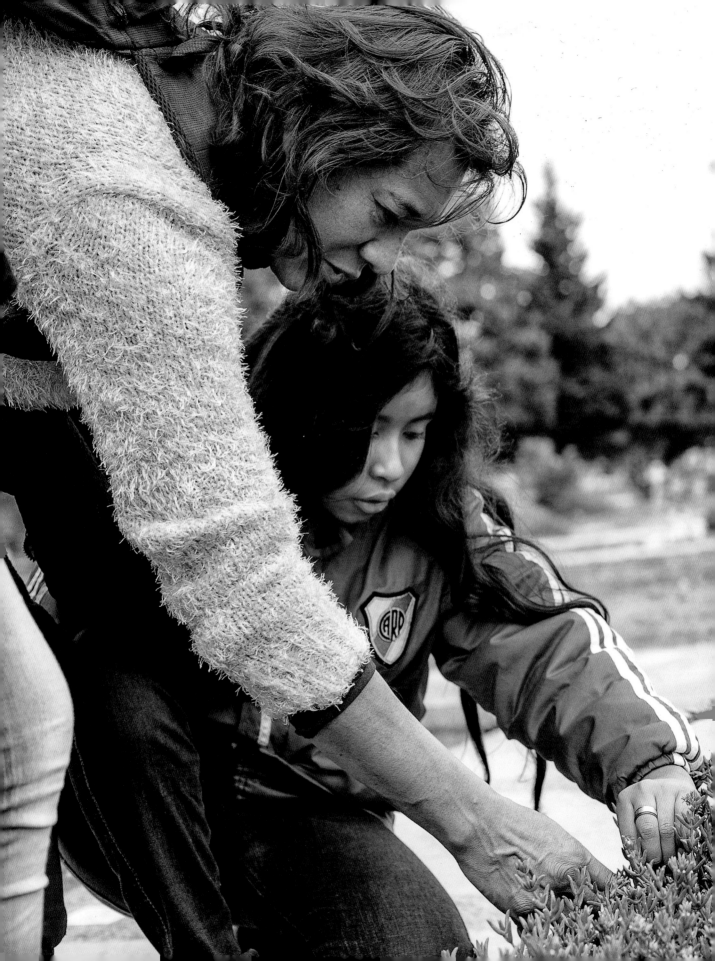

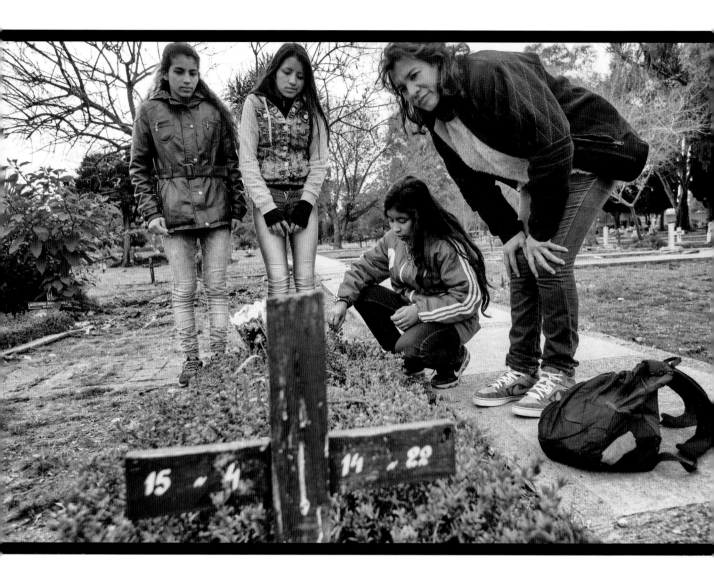

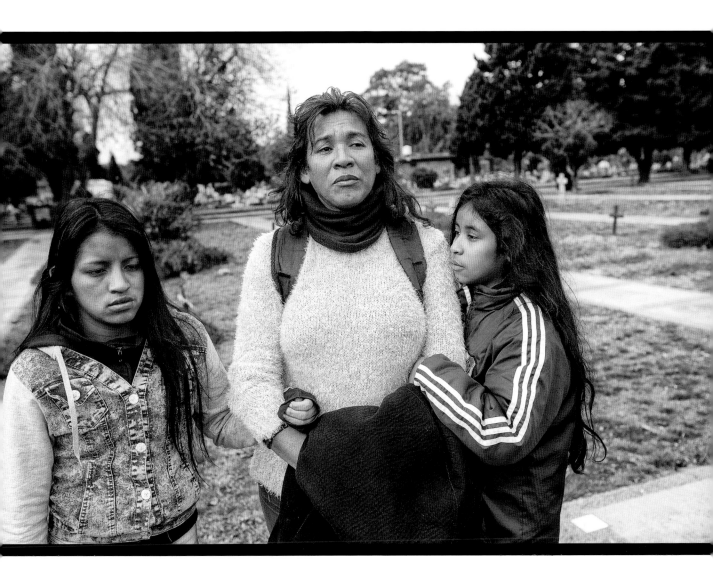

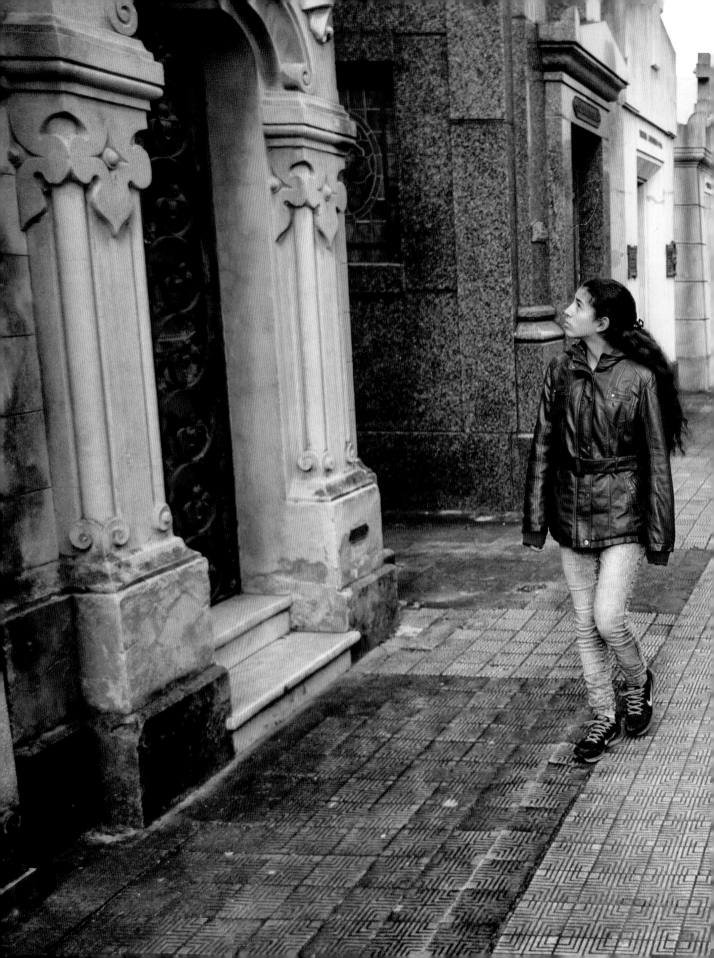

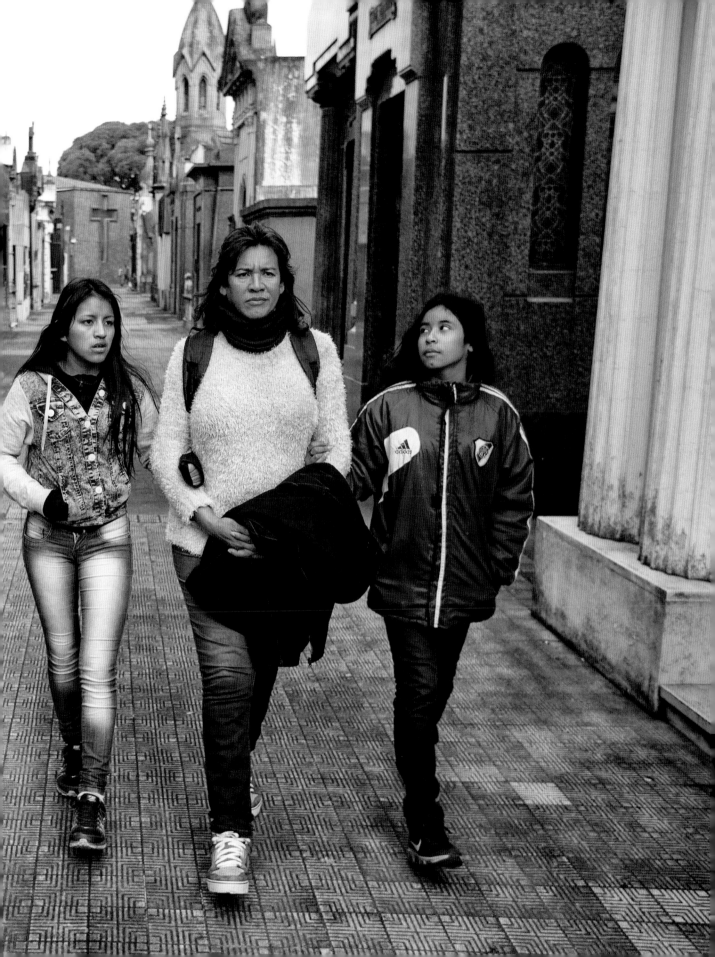

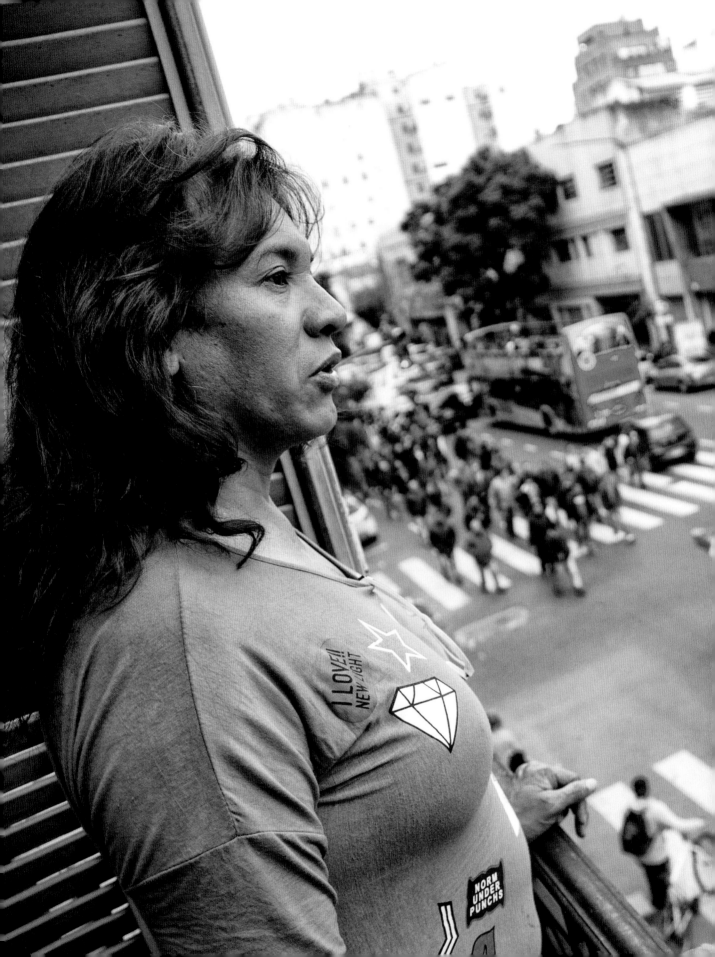

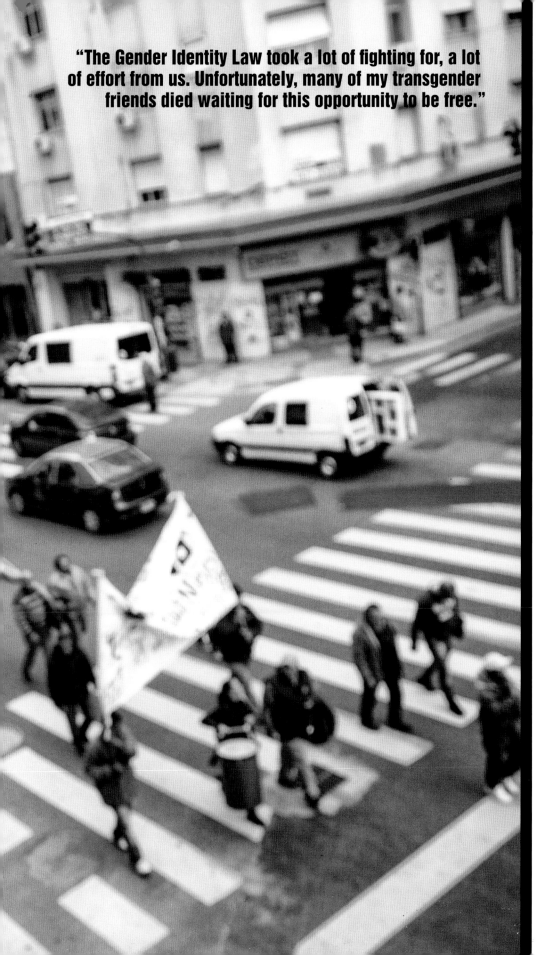

"The Gender Identity Law took a lot of fighting for, a lot of effort from us. Unfortunately, many of my transgender friends died waiting for this opportunity to be free."

Cinthia watches a protest in the street from the library window.

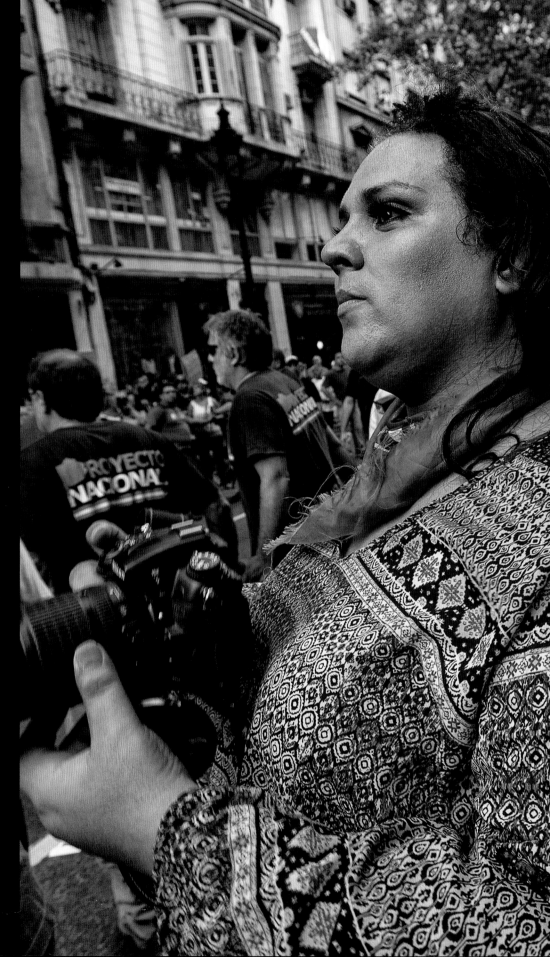

Florencia
Güimaraes
Garcia

Photographer and trans activist Florencia and Alejandro met almost two decades ago but it was only in 2016 that they finally tied the knot, six years after same-sex marriage was made legal in Argentina.

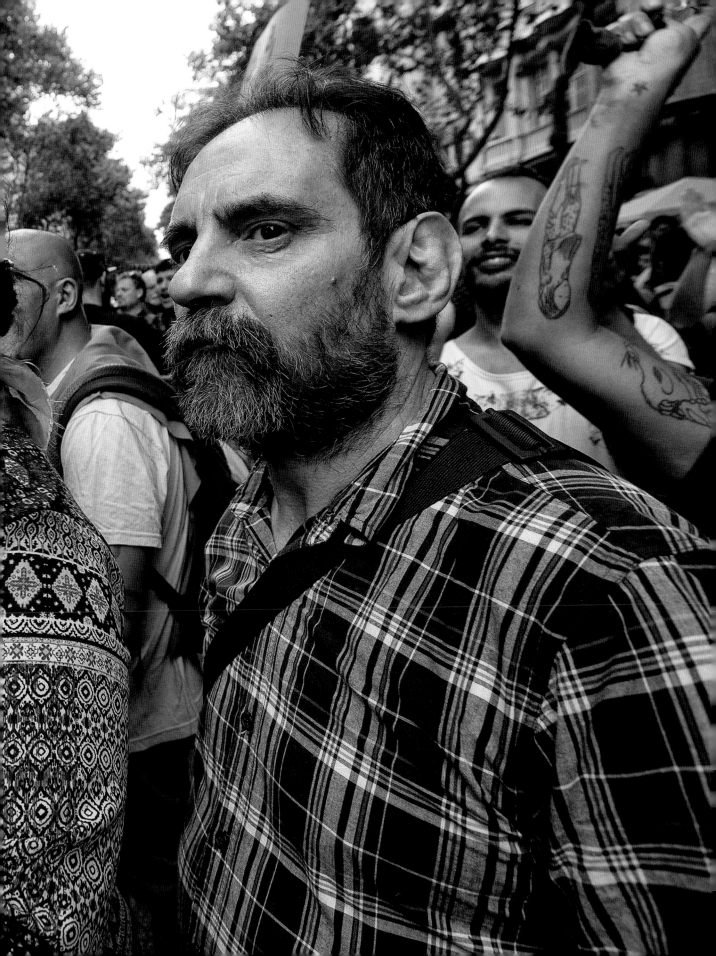

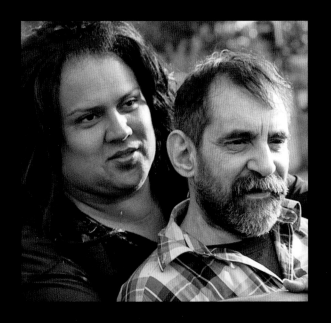

Florencia Güimaraes Garcia started transitioning when she was fourteen. She had realized that her gender expression was in conflict with her body, and, unbeknownst to her parents, she began dressing as a woman. But as usually happens with transgender women in Latin America, Florencia was forced to leave her family when she eventually came out. With no home and at her wit's end, she had no choice but to pursue sex work.

Florencia met Alejandro Pablo Rodriguez through mutual friends in 2000. Alejandro was a veteran of the Falklands War with Britain, and although he was twenty years Florencia's senior, they fell in love and their relationship flourished. With Alejandro's support, Florencia stopped doing sex work and embarked on a new life. She

threw herself into social activism, taking part in a growing movement defending transgender rights in Argentina. The activists successfully fought for the approval of the Ley de Identidad de Género, or Gender Identity Law, considered the most progressive legislation in the world protecting equal rights for transgender people. In 2016, after the death of the internationally recognized transgender leader Lohana Berkins, the Asociación de Lucha por la Identidad Travesti y Transexual (Association for the Struggle of Transvestite and Transexual Identity) appointed Florencia as their president.

Florencia has not undergone gender-reassignment surgery and she calls herself *chica trans,* a transvestite, and won't use the term *transgénero.* Transvestite is the preferred self-denomination of older generations of trans women in the South American nation.

Today, Florencia is also a freelance photographer covering LGBTQ issues for local newspapers and in particular documenting the lives of the transgender community in Buenos Aires. She is studying political science at the Universidad Nacional de General Sarmiento. She keeps a Facebook page, Furia Trava Noticias, to inform the trans community about trans activism. She is also writing an autobiography, *La Roy: Revolución de una trava.*

Alejandro and Florencia were legally married on March 4, 2016. They are inseparable companions, spending a great deal of their time with Florencia's nephews and nieces—part of a family they have created and nurtured together.

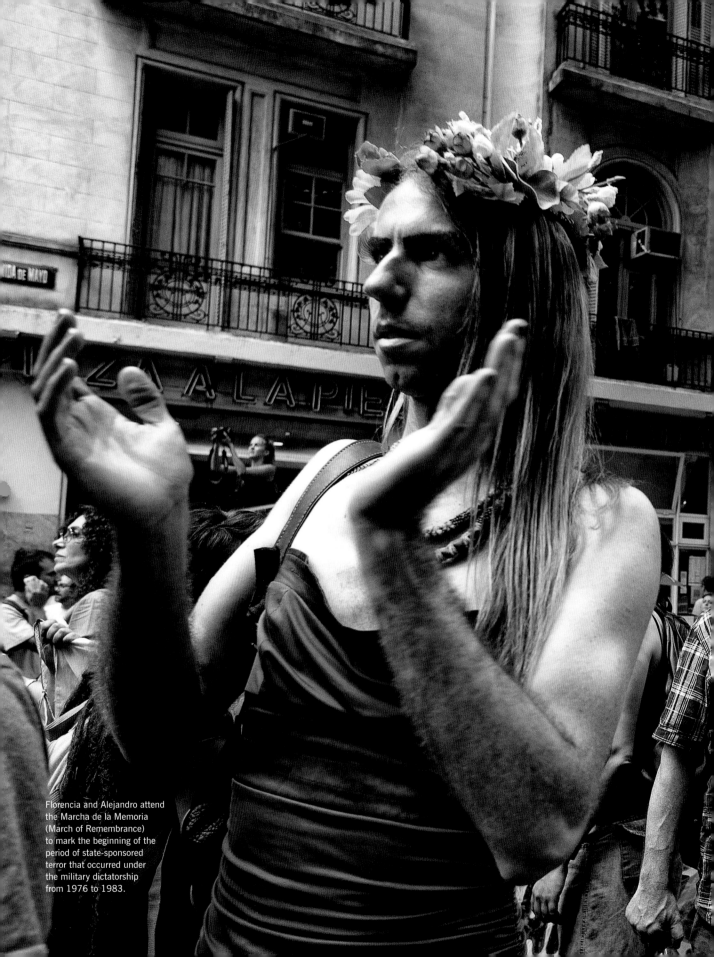

Florencia and Alejandro attend the Marcha de la Memoria (March of Remembrance) to mark the beginning of the period of state-sponsored terror that occurred under the military dictatorship from 1976 to 1983.

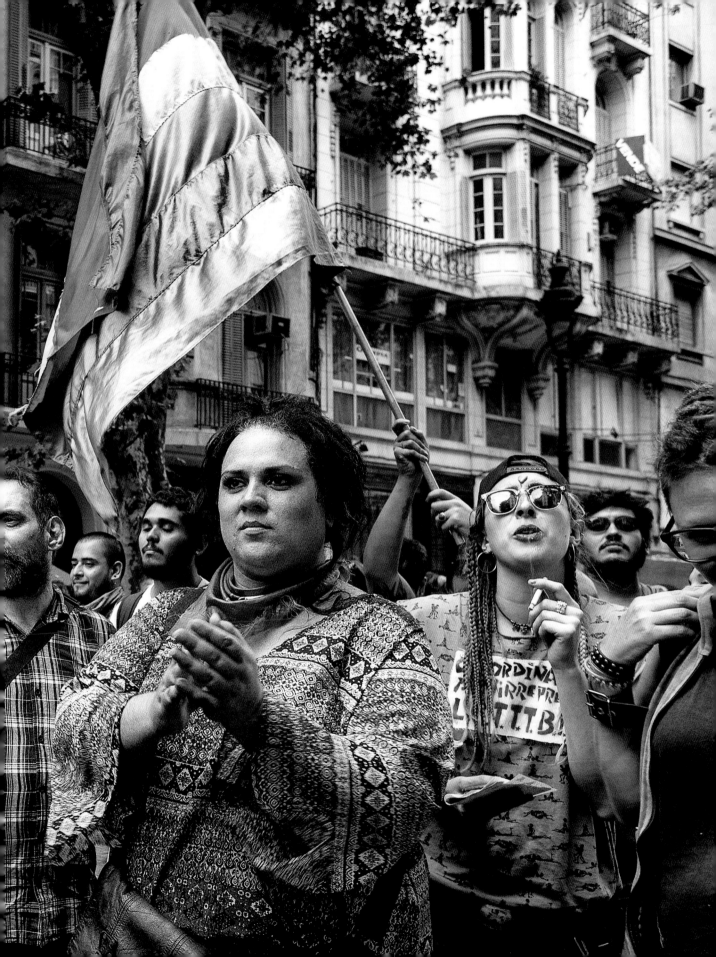

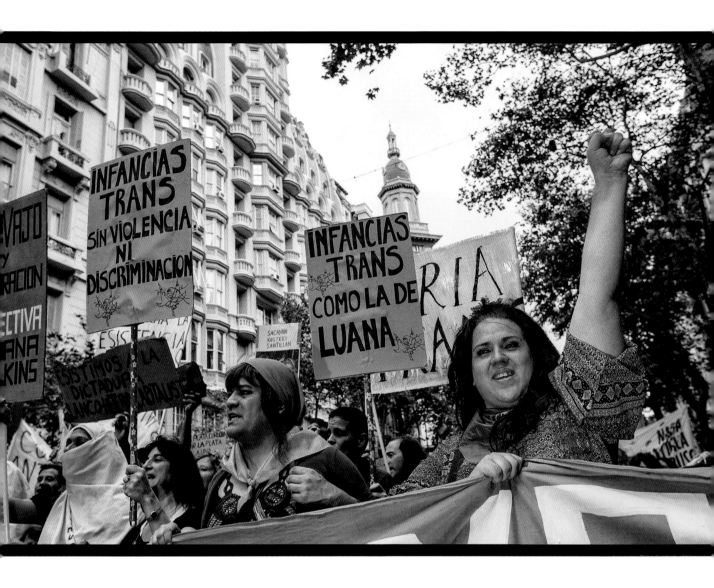

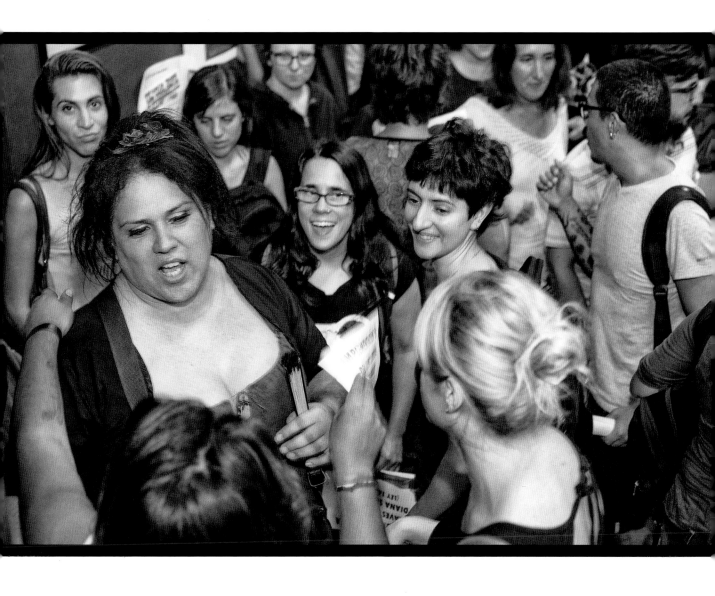

Florencia is approached
by the public after her
presentation on *Cumbia,
Copeteo y Lagrimas*,
a book by the late
transgender leader Lohana
Berkins, who was also
Florencia's mentor.

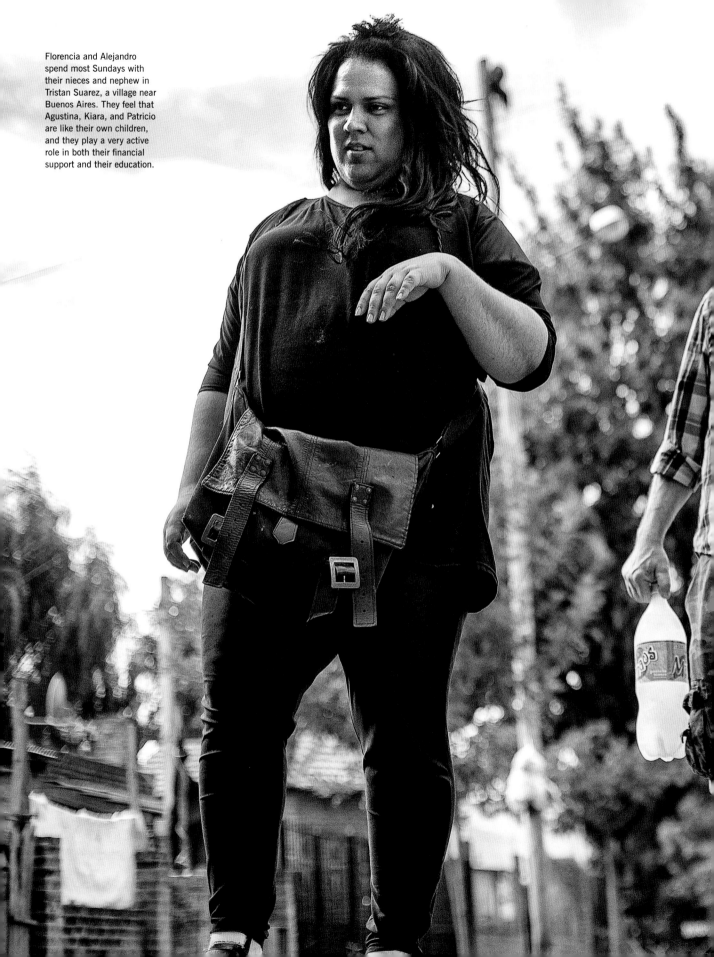

Florencia and Alejandro spend most Sundays with their nieces and nephew in Tristan Suarez, a village near Buenos Aires. They feel that Agustina, Kiara, and Patricio are like their own children, and they play a very active role in both their financial support and their education.

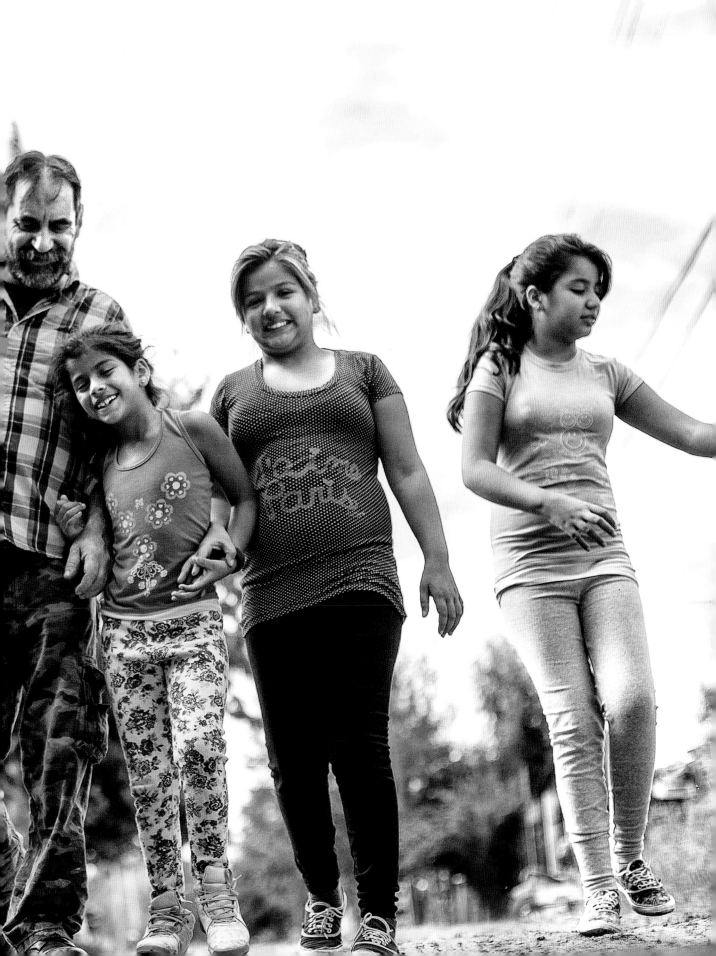

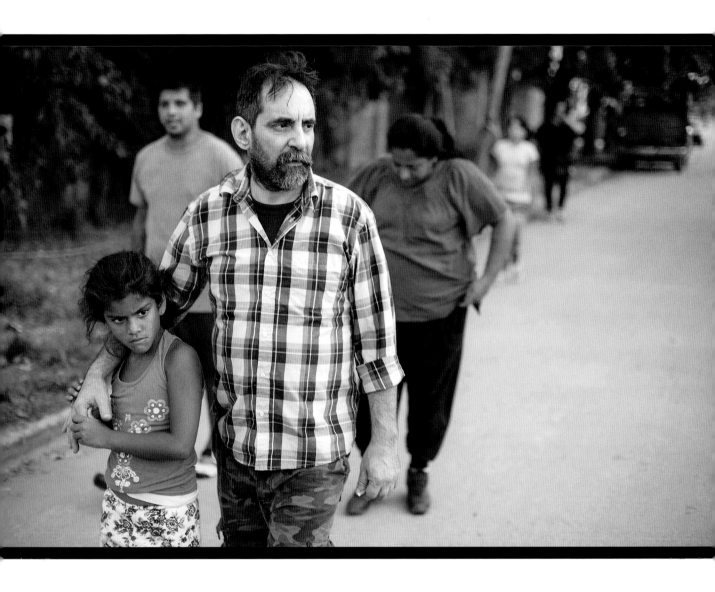

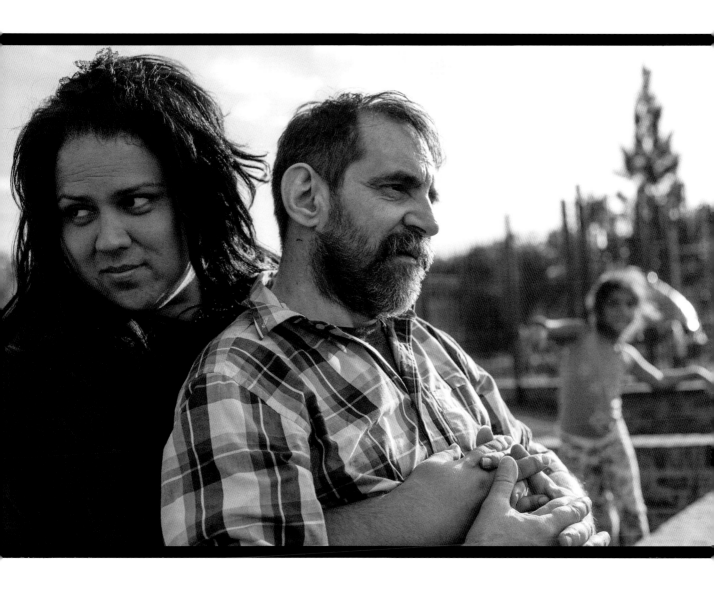

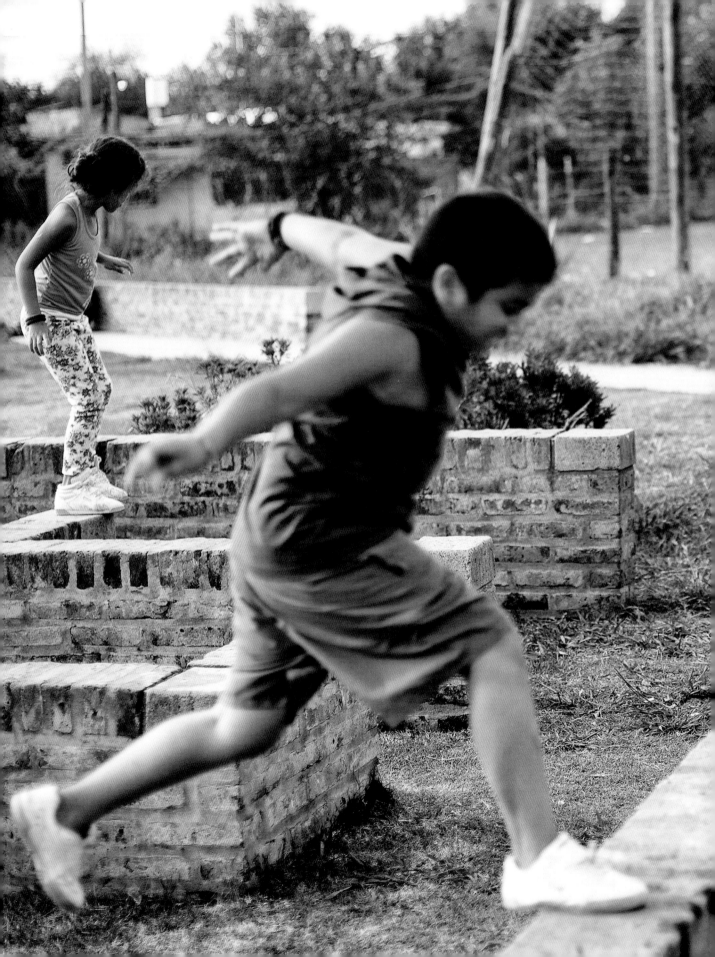

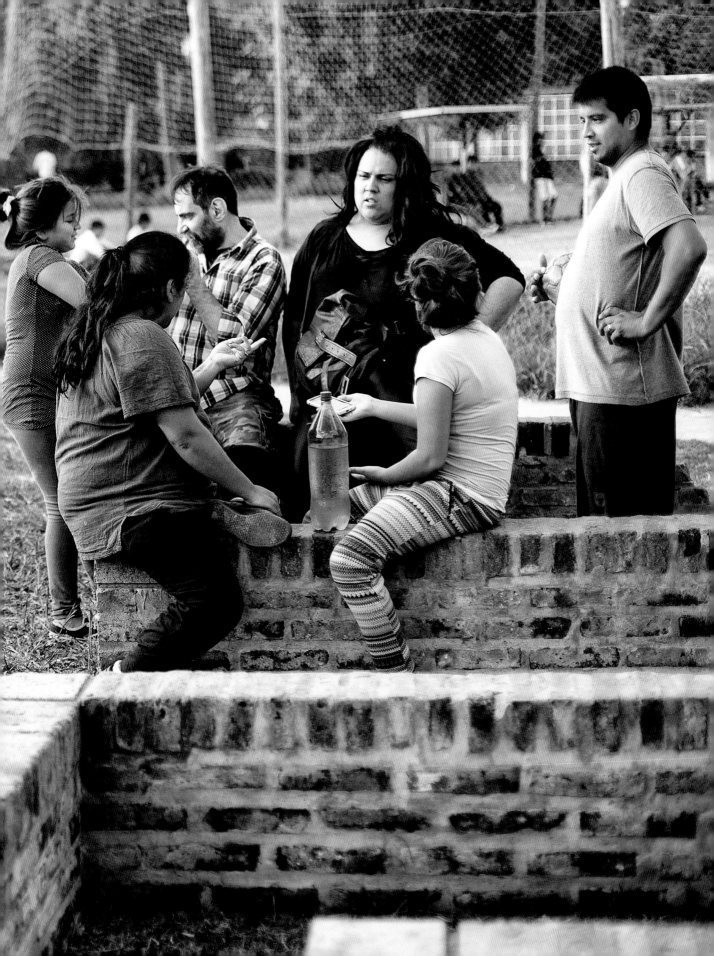

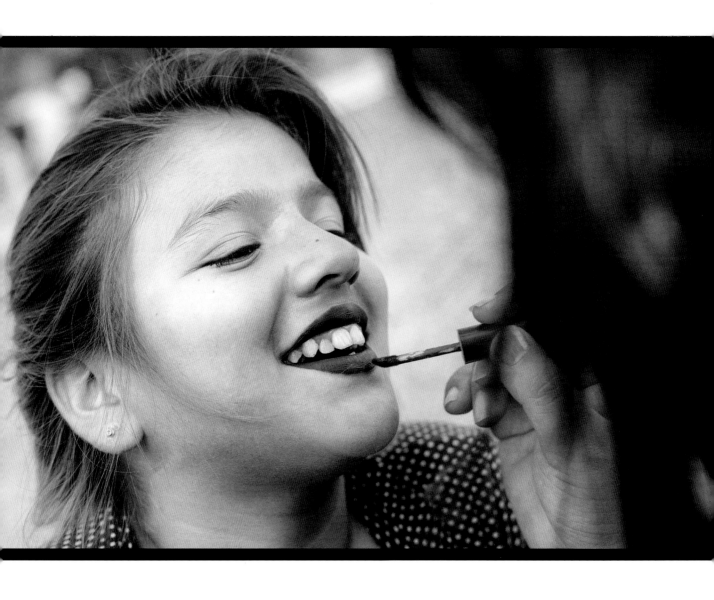

Florencia applies lipstick
to her niece Agustina.
A powerful influence,
Florencia provides a great
support to Agustina as
she becomes a teenager.

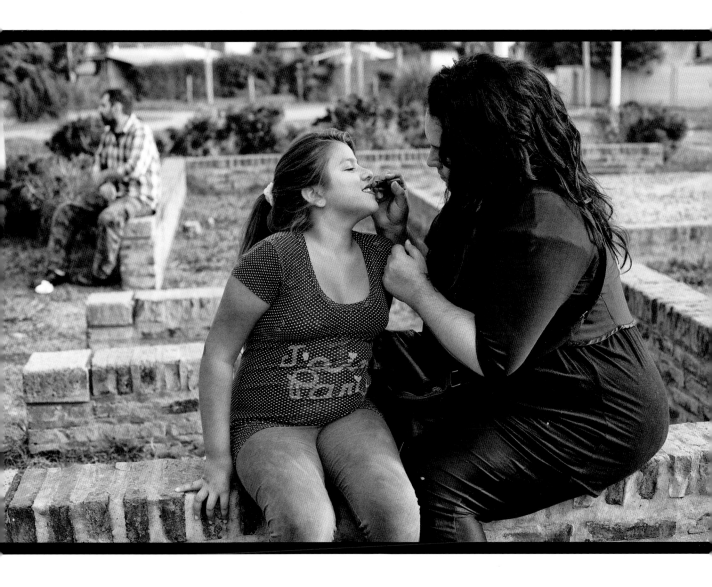

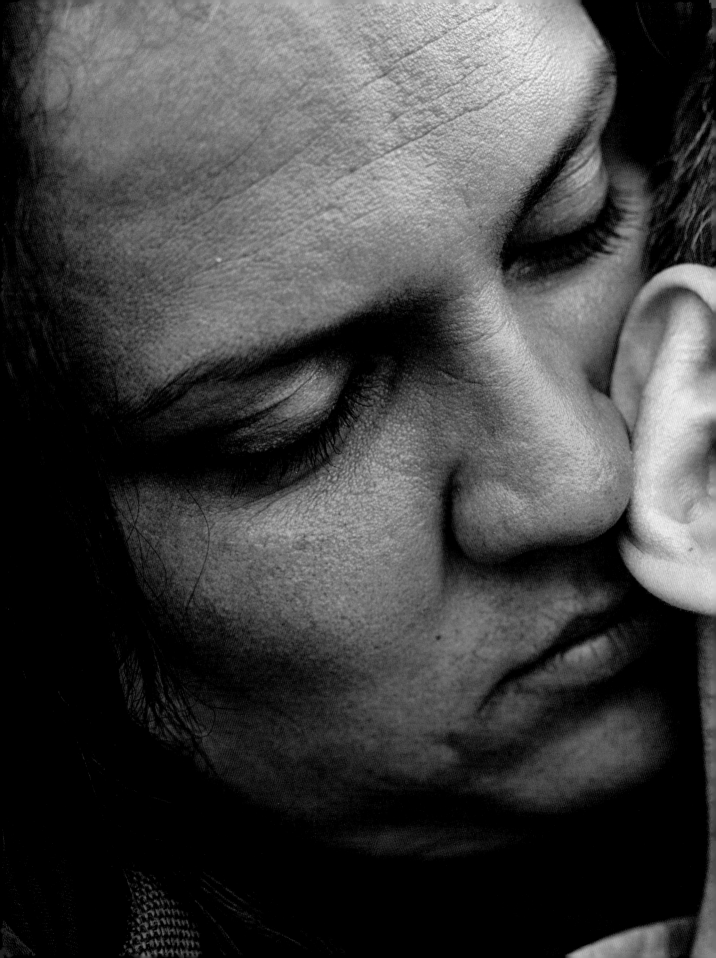

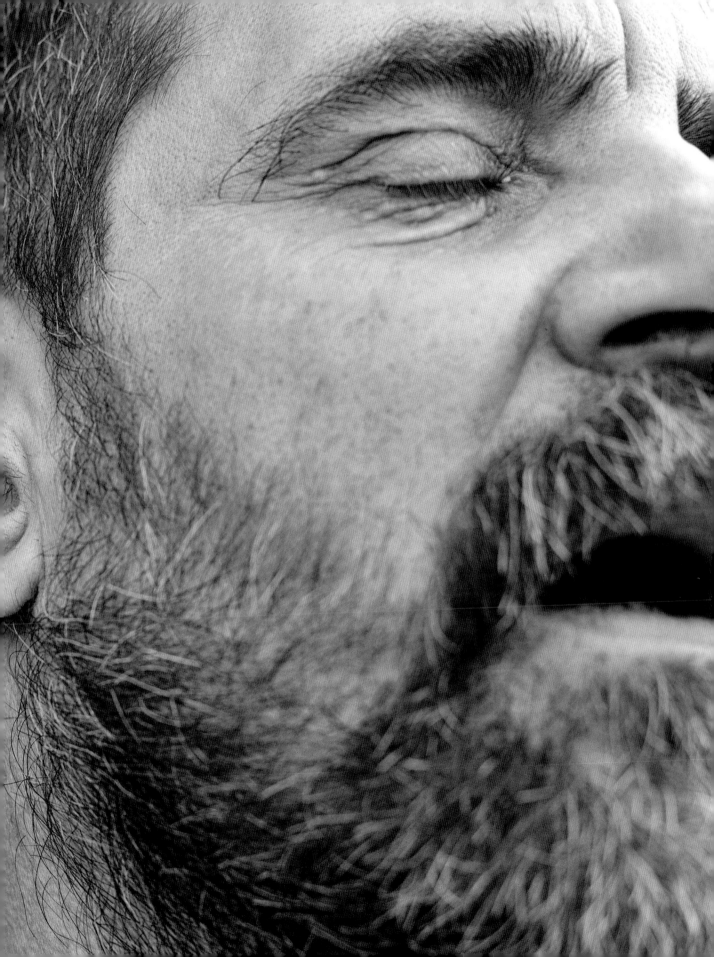

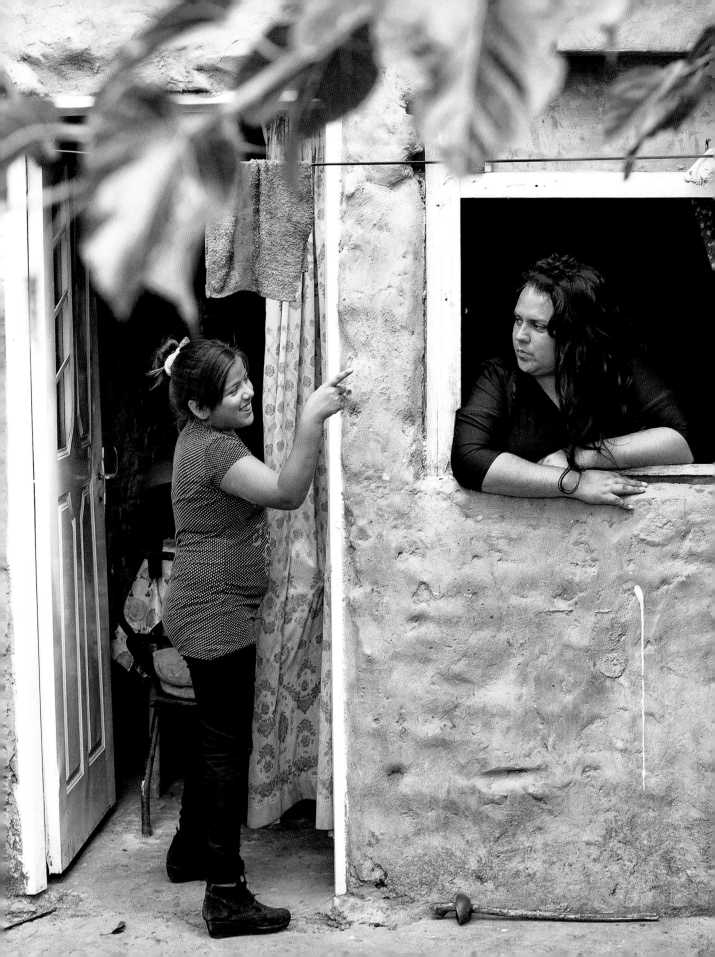

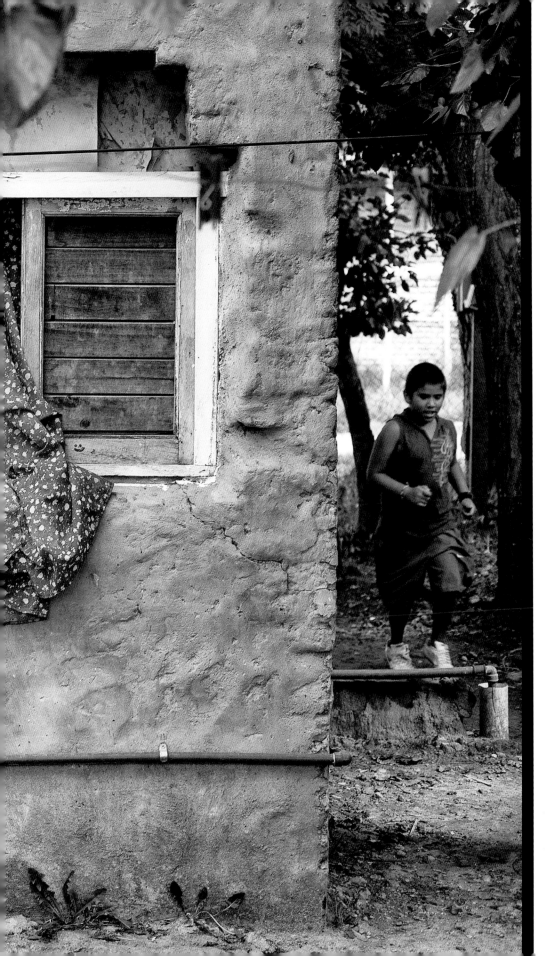

During a Sunday visit from her favorite aunt, eleven-year-old Agustina talks to Florencia while her brother Patricio runs around in the background.

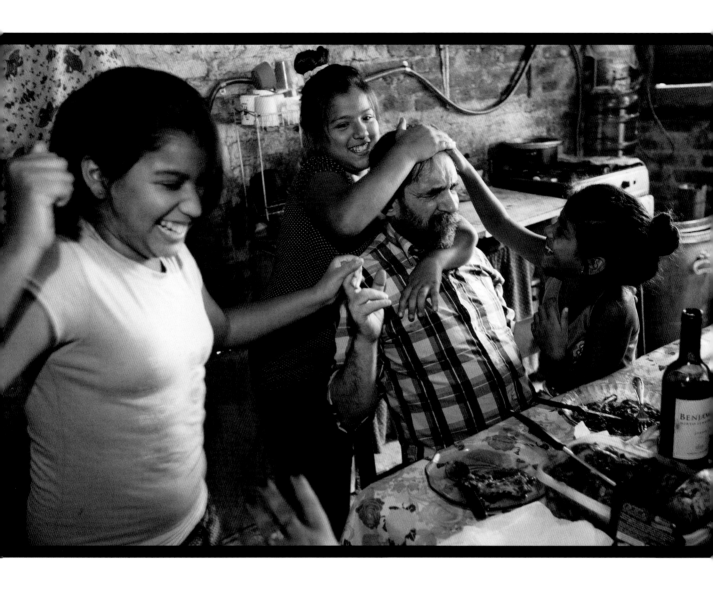

The children play with
Alejandro after Sunday
lunch. Later, the girls
spend time in their
room with their aunt.

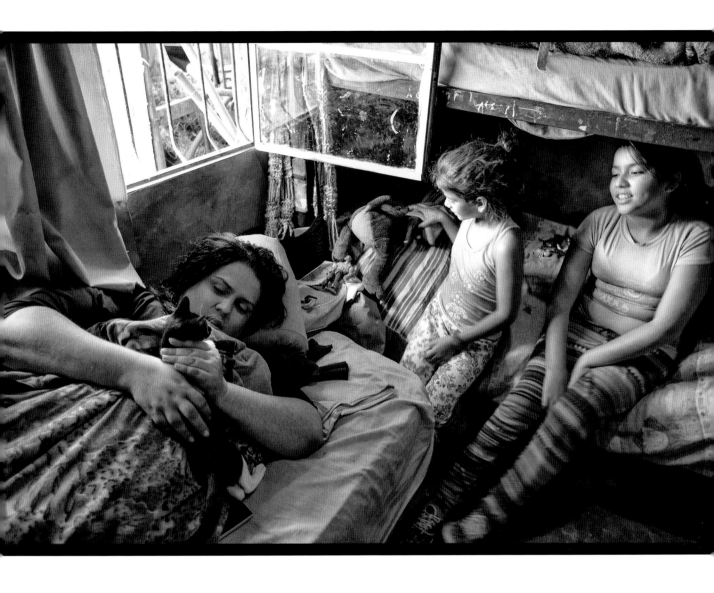

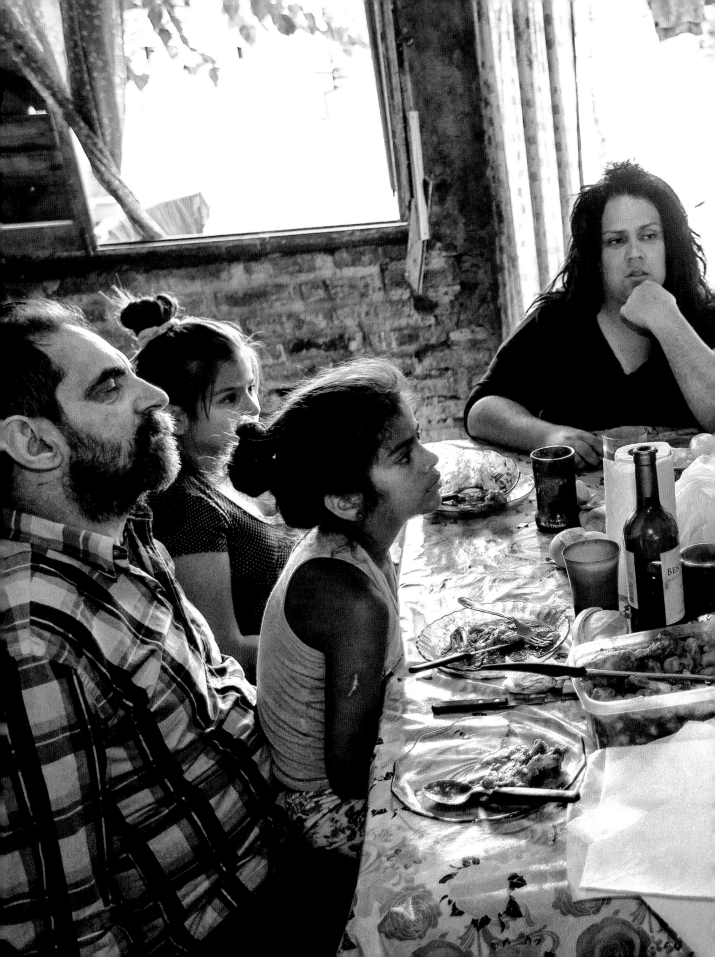

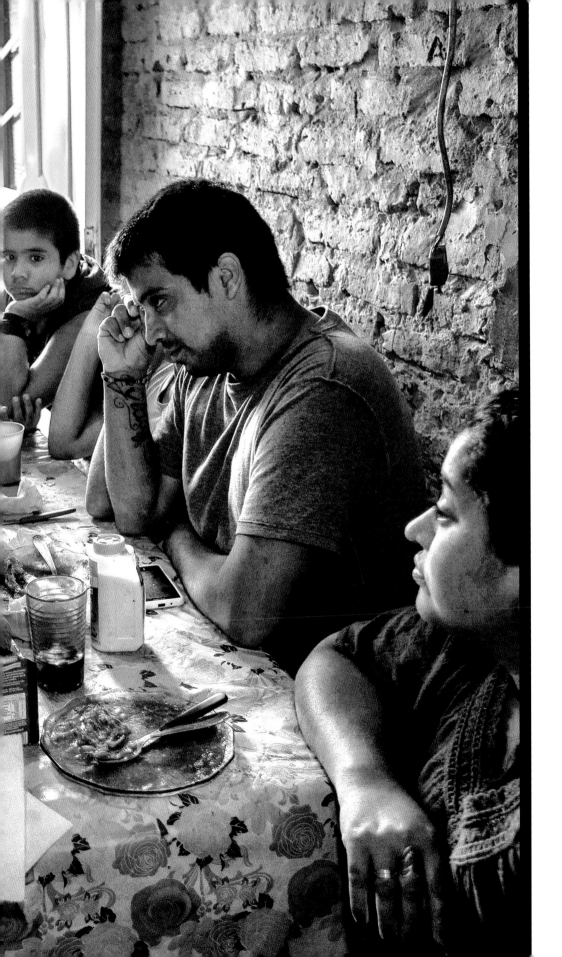

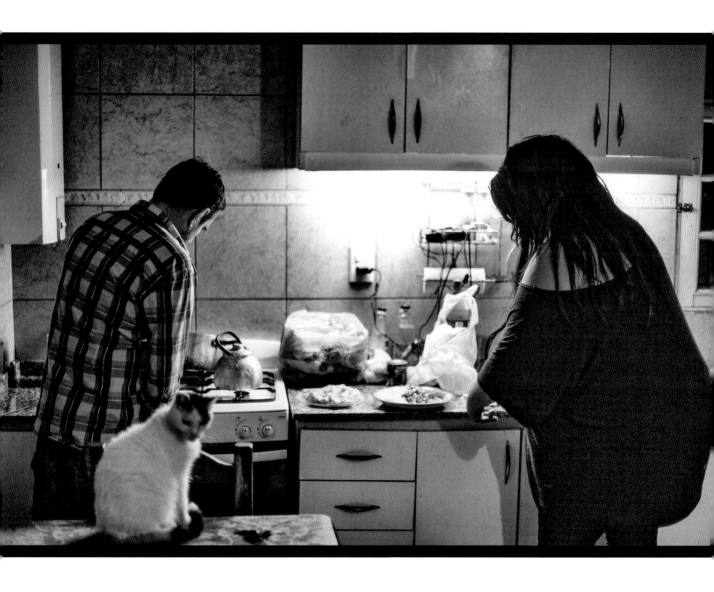

Alejandro and
Florencia fix a quick
dinner before going
to bed at their home
in Matanza.

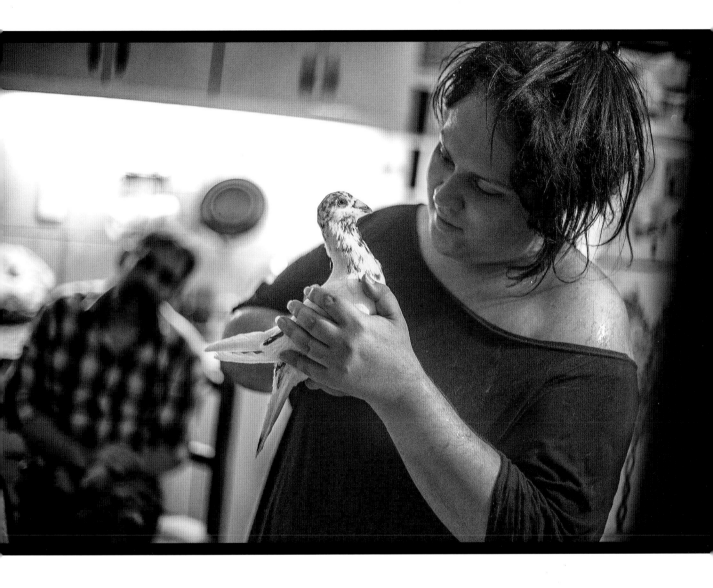

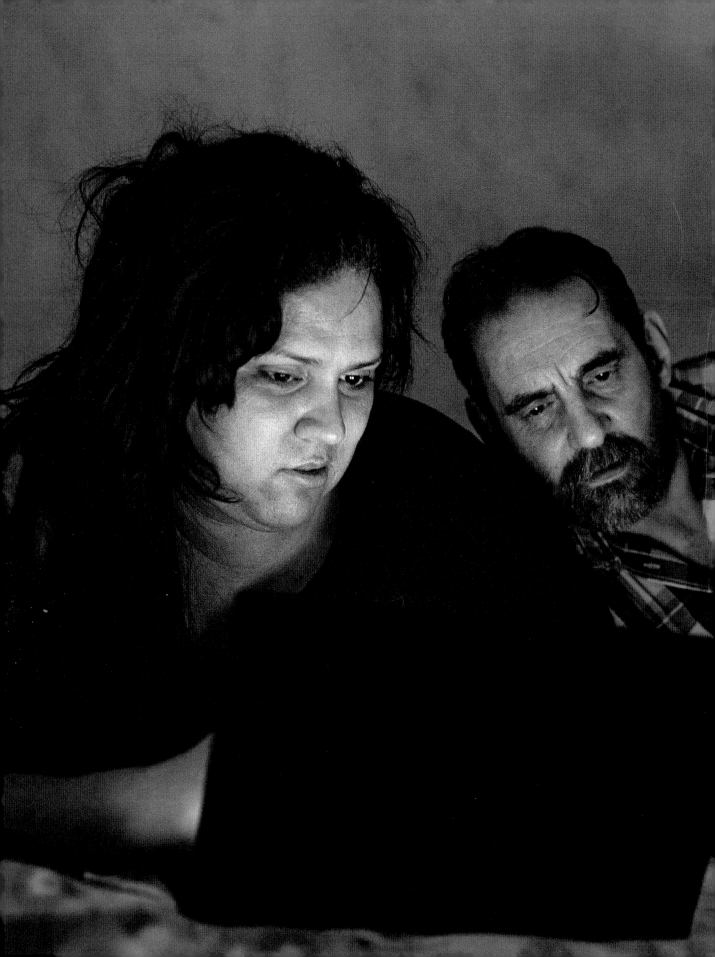

"I don't want to be a man or a woman.
I want to be a transvestite."

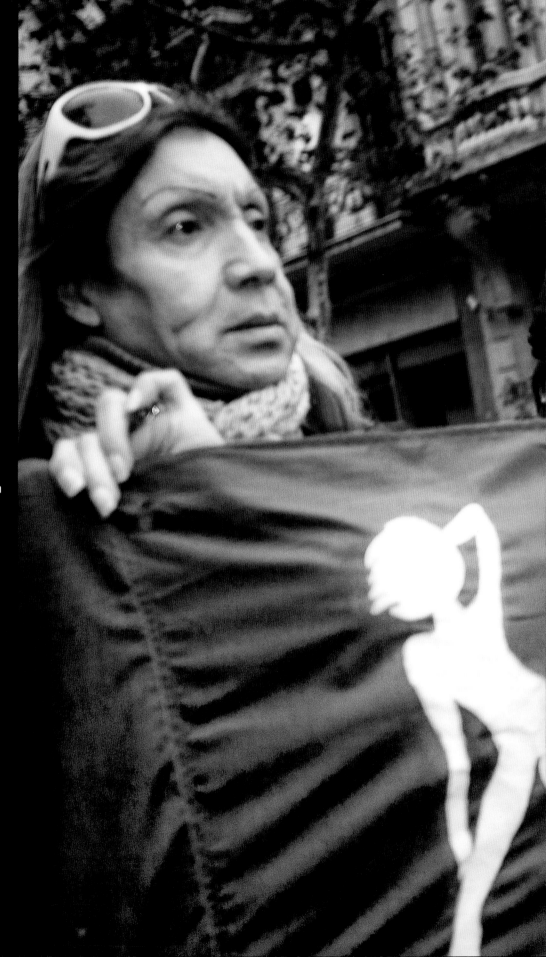

El Gondolín

Once a family-run hotel in the Villa Crespo neighborhood of central Buenos Aires, El Gondolín is now inhabited by around fifty transgender women, most of them underprivileged migrants from northern Argentina.

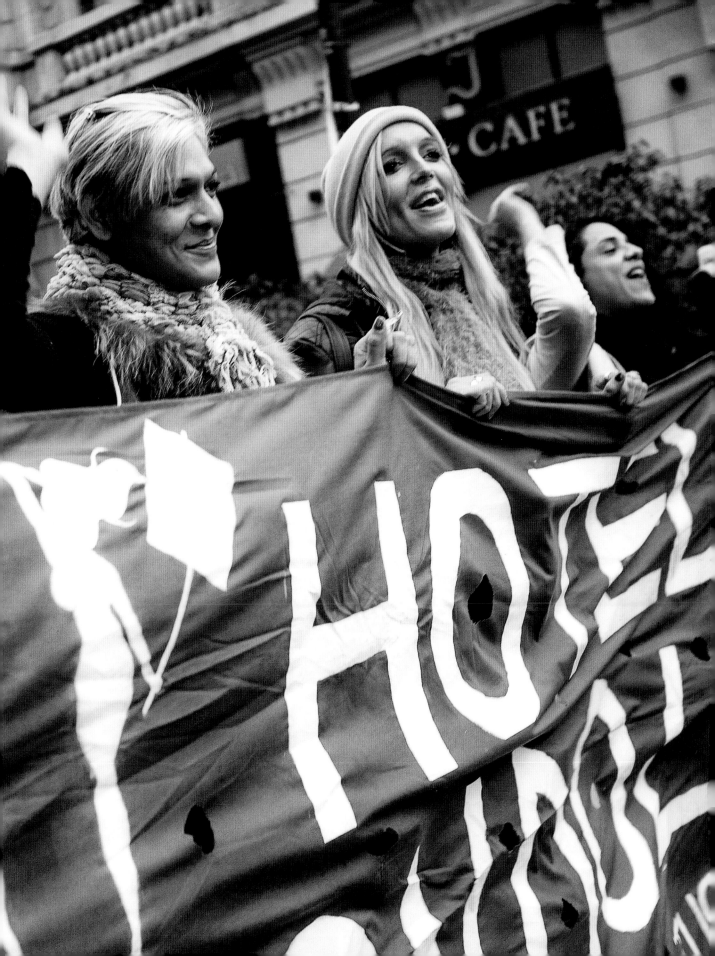

The late eighties saw the first of a few young transgender women who came from Argentina's northern states of Salta and Jujuy and started living there. At the time, as it still is today, it was difficult for transgender people to rent a room in a hotel, due in part to the contradiction between their ID card and their physical appearance. The Gondolín's owner soon turned this to his advantage, charging higher fees because he knew these transgender women had nowhere else to go. Moreover, the Gondolín was conveniently located near the red-light districts of Palermo and Constitución, where most transgender migrants, without access to any other forms of employment, engaged in sex work.

"El Gondolín is a place where we all meet and share the things we go through."

In the late nineties, there was a dispute between the hotel's transgender occupants and its owner over transphobic discrimination. Not long after that, in 2000, the Gondolín's owner passed away and the transgender women took charge, transforming the hotel into what it is now: a shelter for transgender women.

El Gondolín is a self-managed squat. About fifty transgender women live in the building. The more senior leaders assign cleaning and cooking tasks, and everyone pays a small fee for utilities such as electricity and cooking gas. In many cases, the women are still in their teens, kicked out of their homes by their parents or physically abused by people in their hometowns. With few options left, they come to Buenos Aires in search of work and a better life.

In 2016, the French police charged a former transgender resident of El Gondolín, then living in France, with human trafficking. The scheme involved bringing young transgender women from Argentina to Europe and forcing them into sex work. It was a damaging blow to the community, undermining their efforts to continue living in the building. The future is uncertain, and most of the women are afraid that eventually they will have to find accommodations elsewhere.

A smiling Rihanna
Rios sits in front
of El Gondolín.

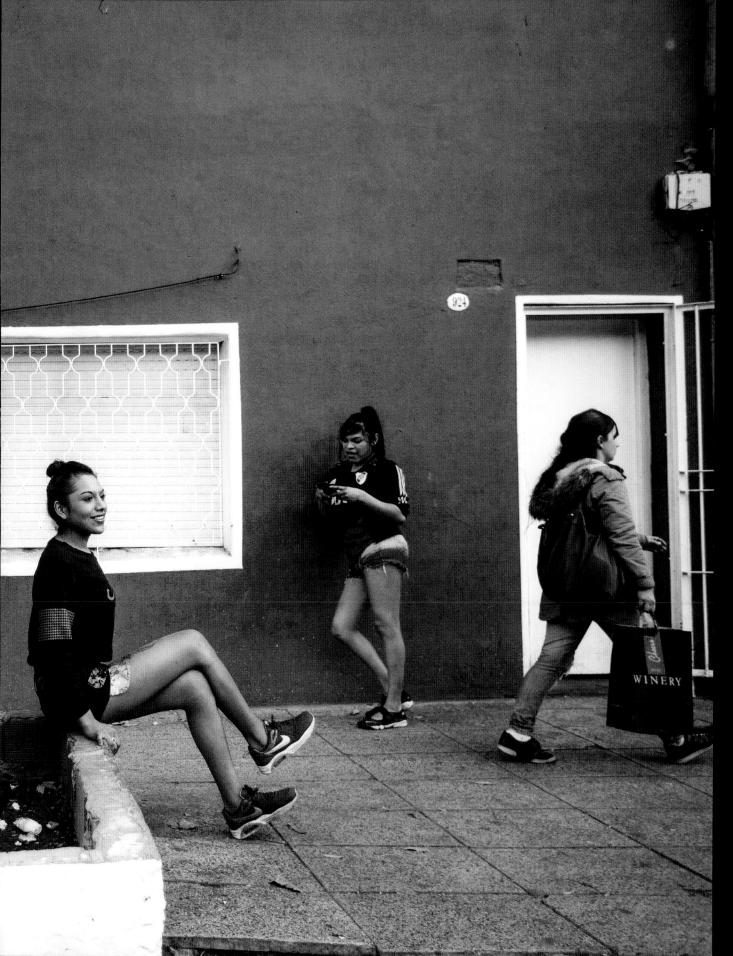

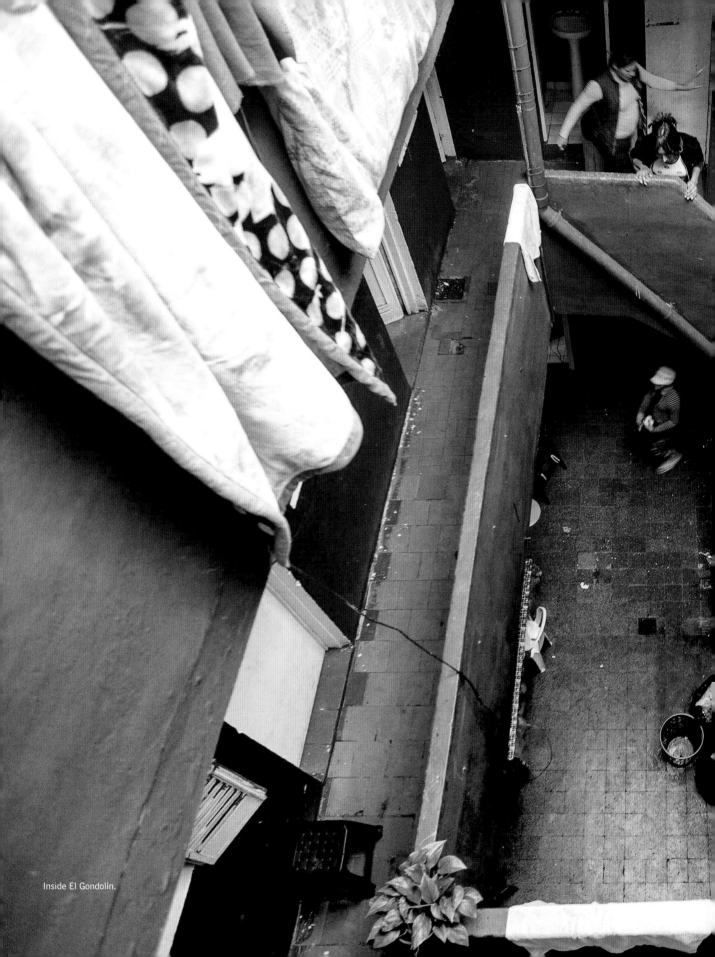

Inside El Gondolín.

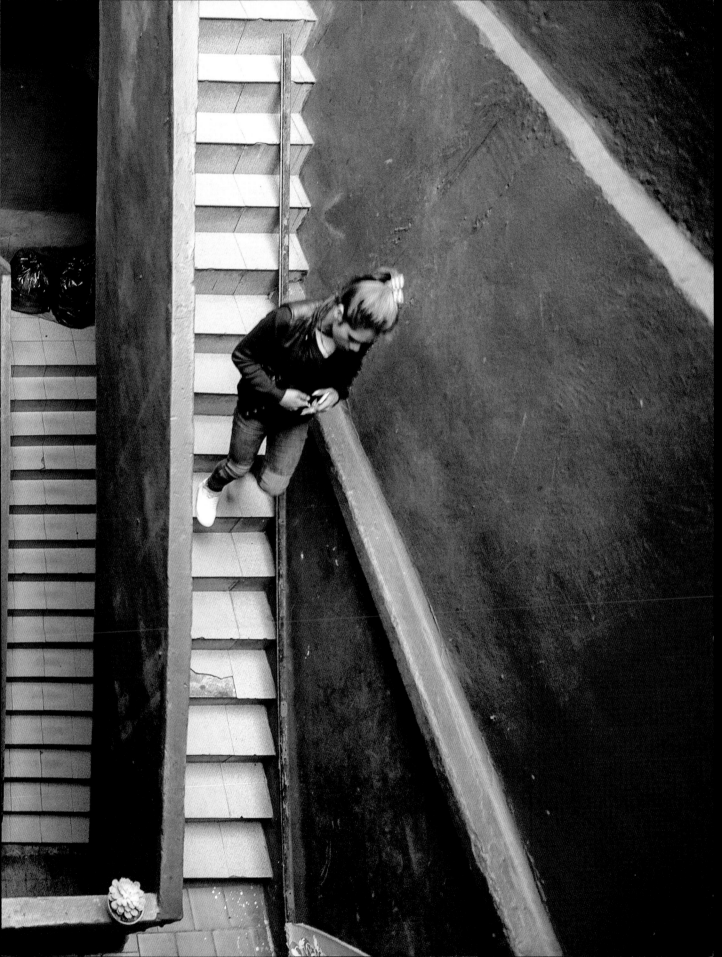

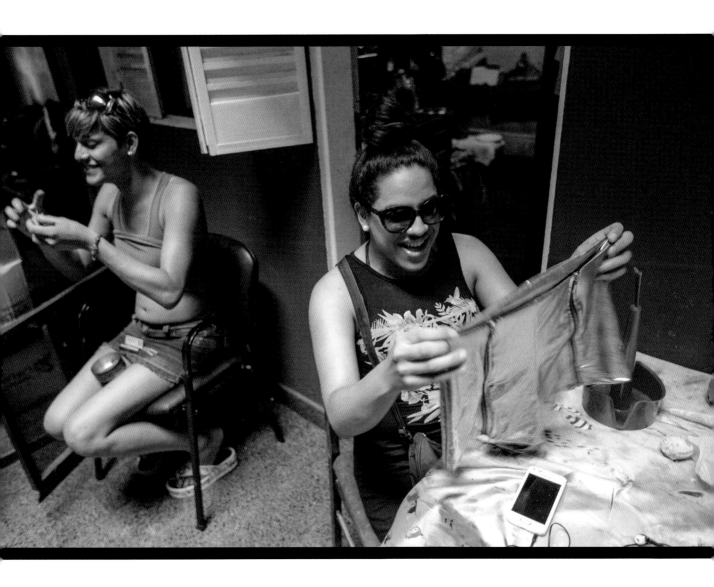

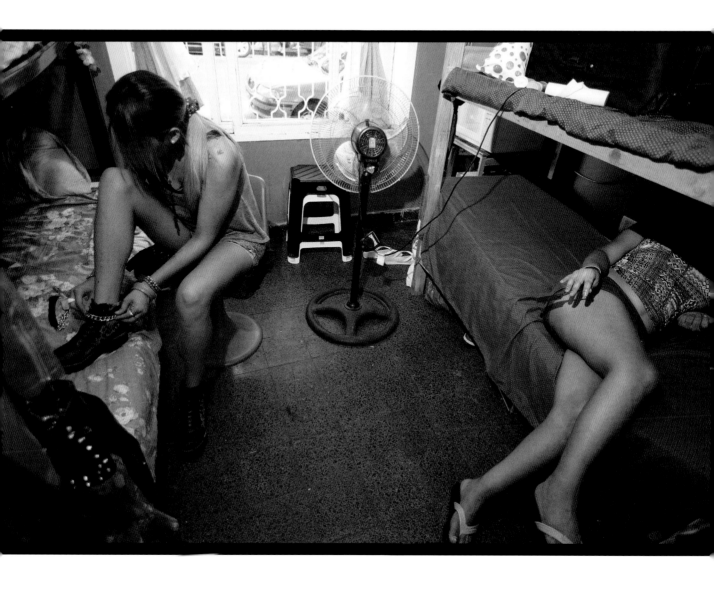

A woman dresses in her room, a space she shares with four other women.

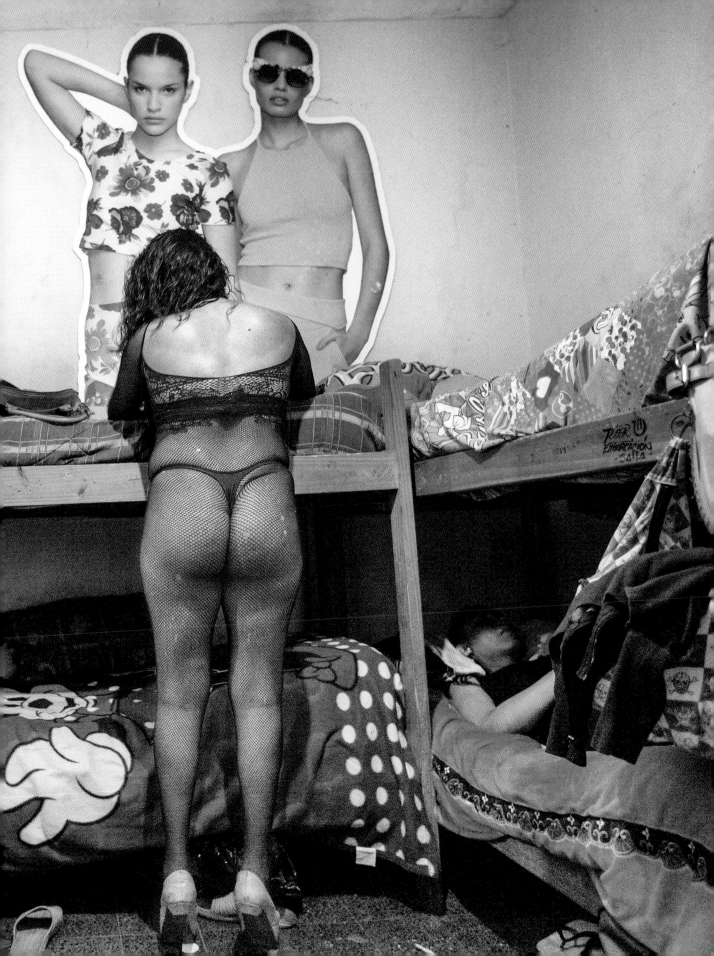

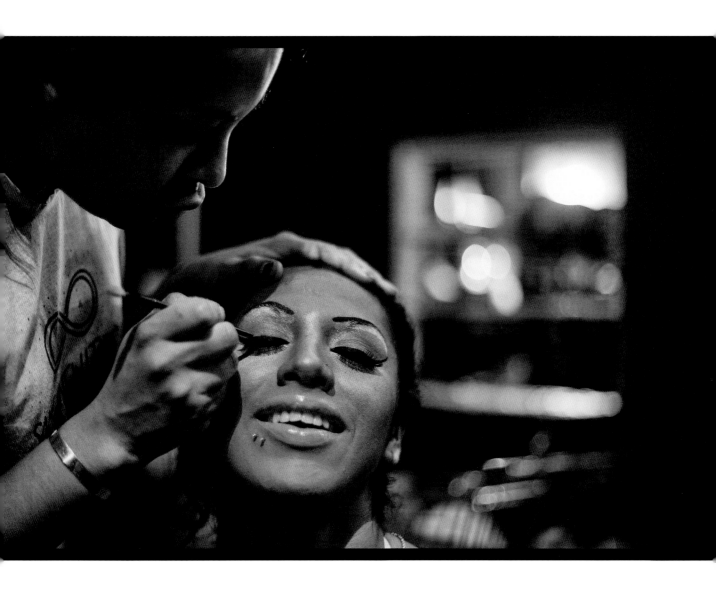

A woman gets ready
to leave El Gondolín
to work in Bosques
de Palermo.

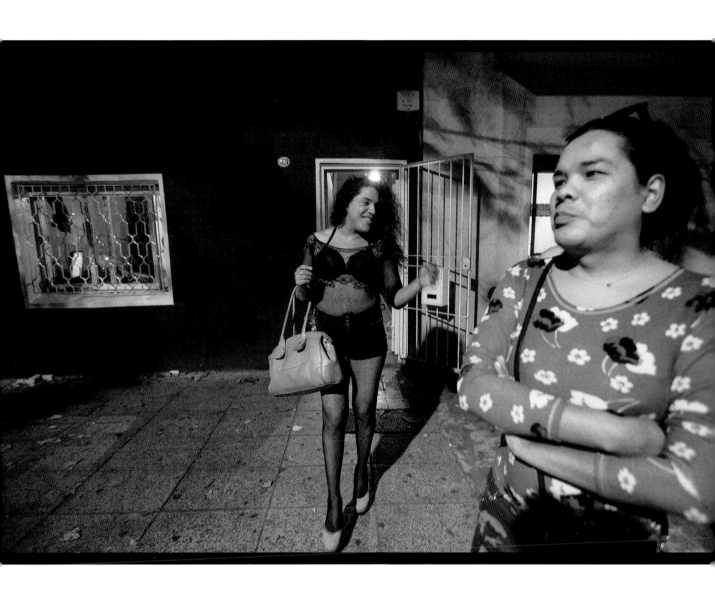

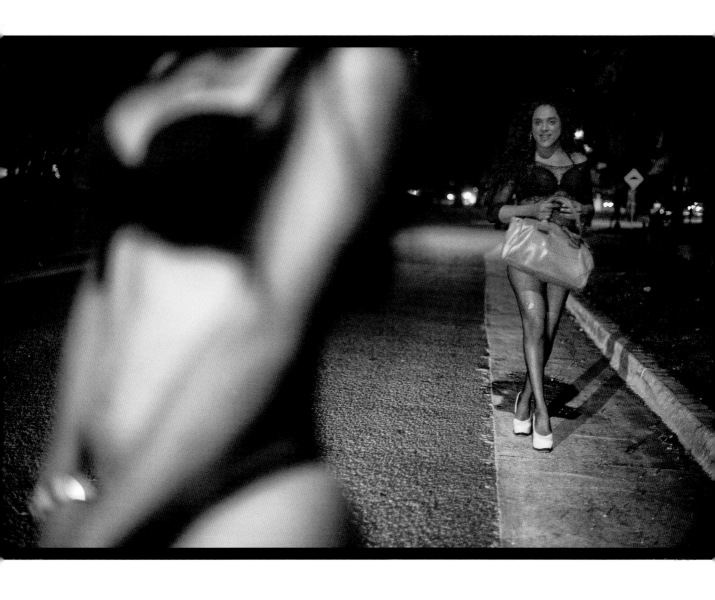

Young transgender
women waiting to be
picked up by customers
in Bosques de Palermo.

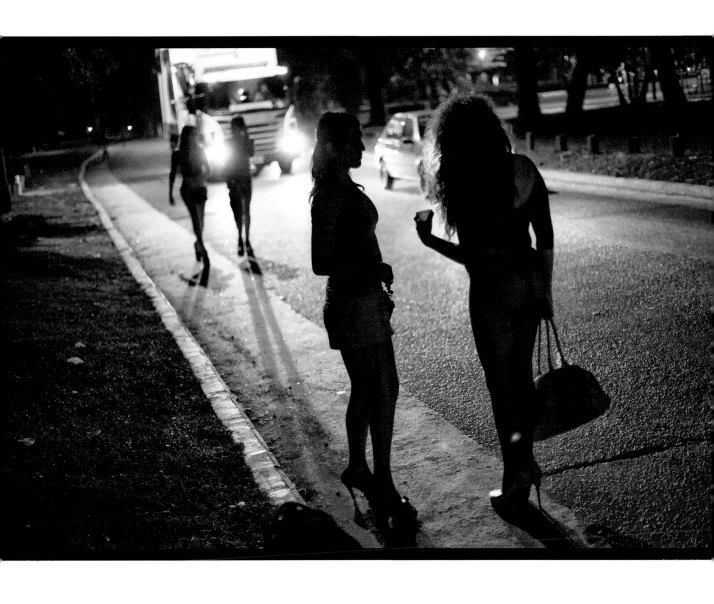

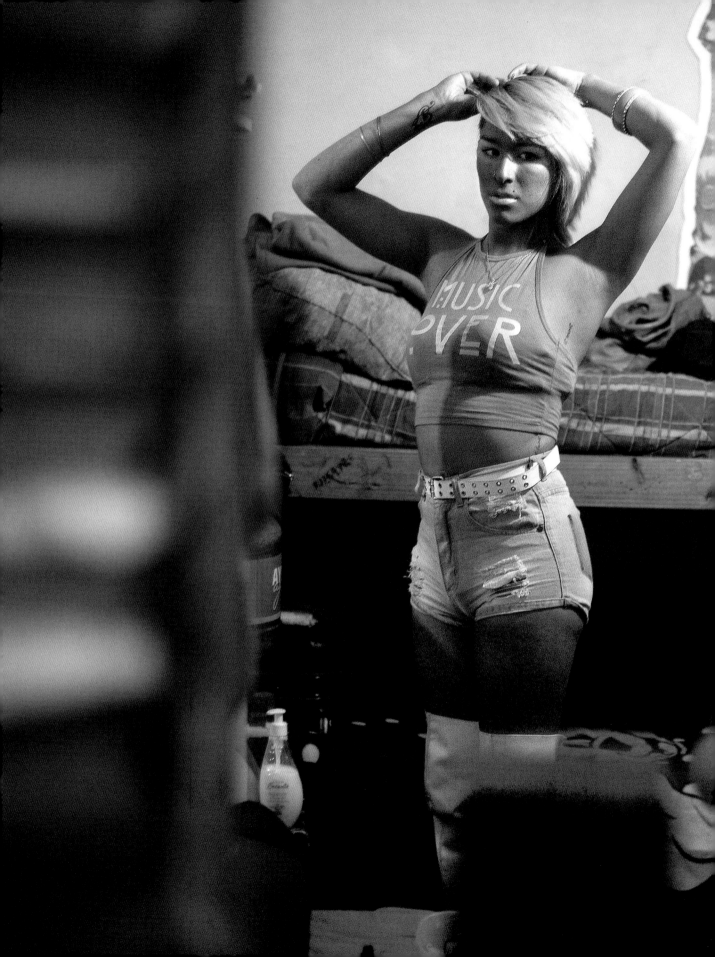

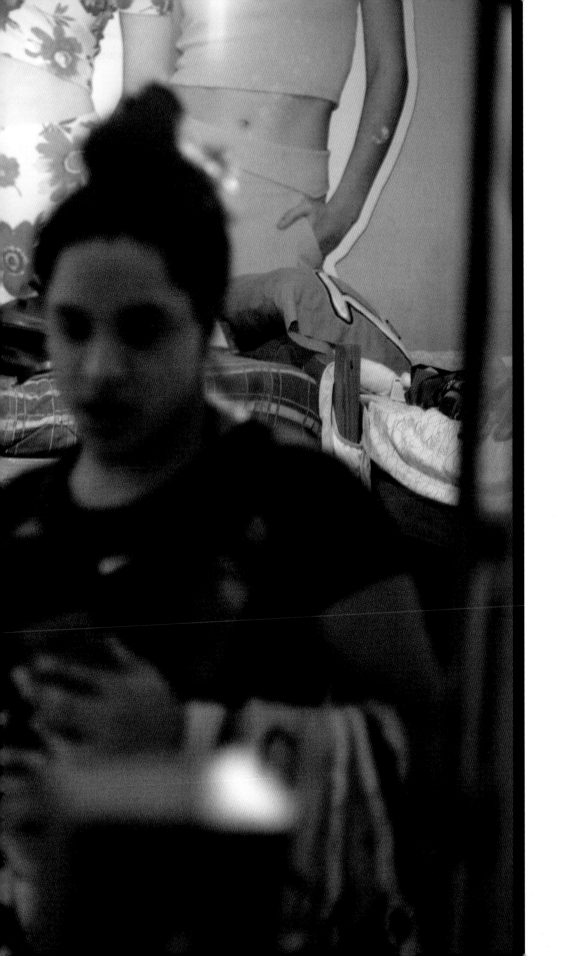

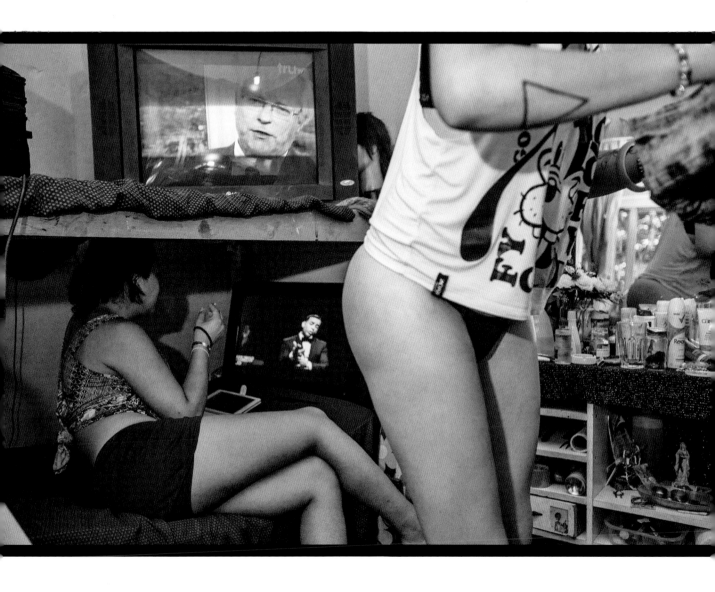

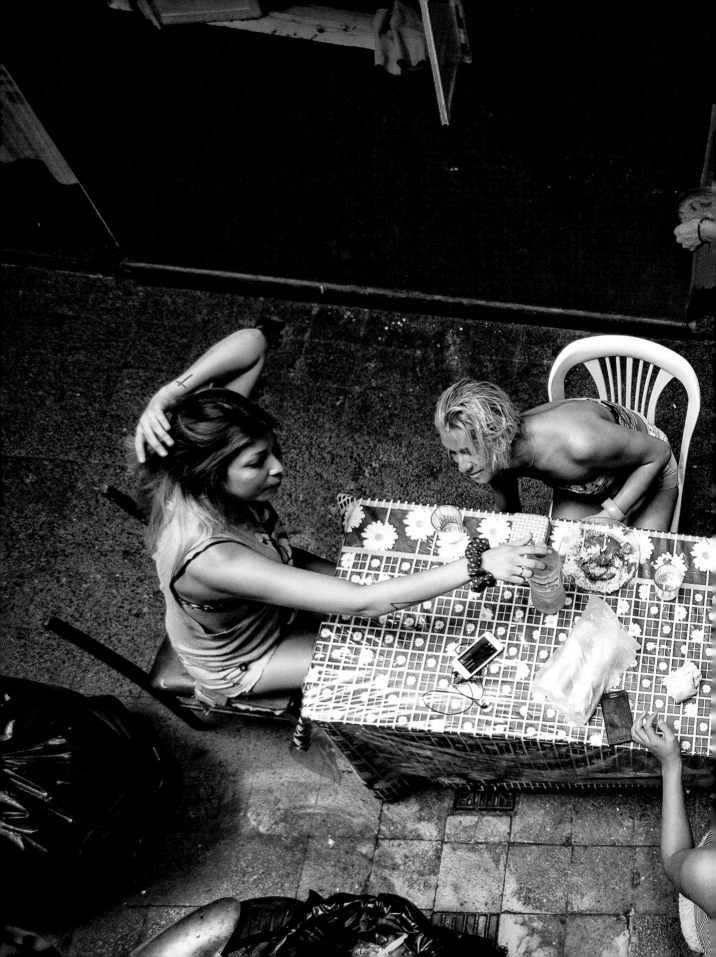

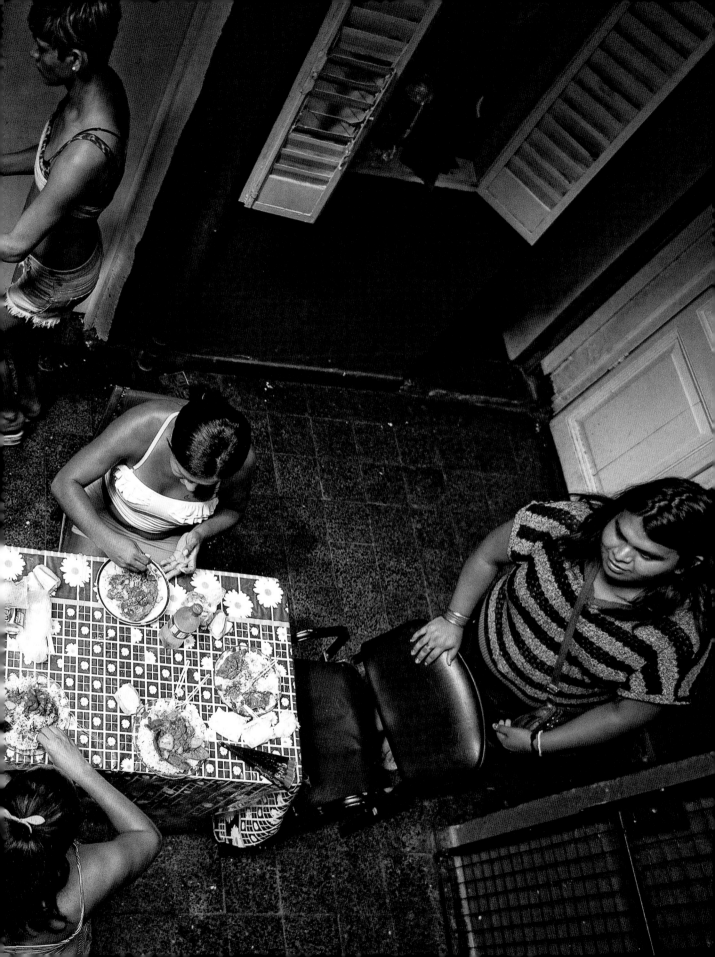

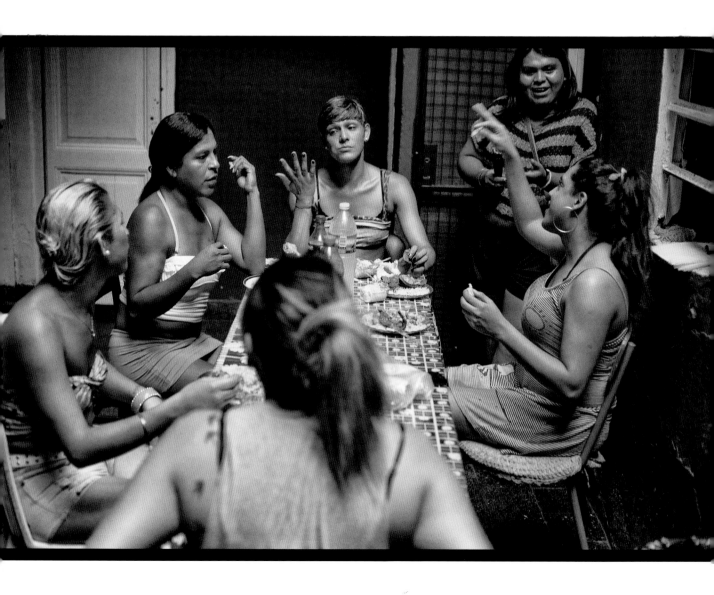

Lunchtime at El
Gondolín, where
the tenants hire a
transgender cook to
prepare their meals.

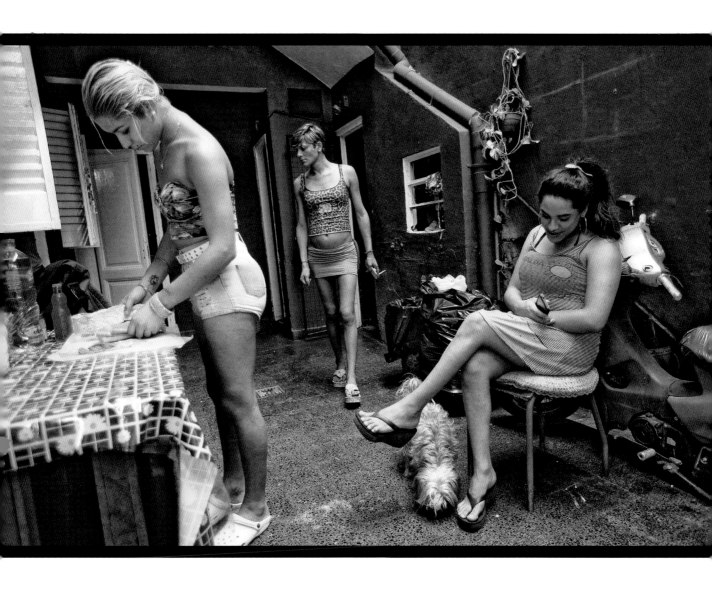

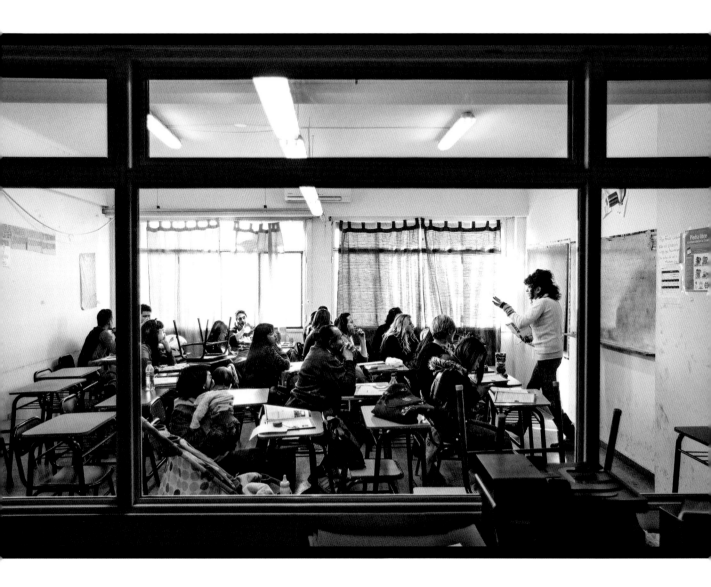

In the afternoons, several women living in El Gondolín attend Mocha Celis, a unique high school created to support the transgender community in Buenos Aires. Mocha Celis provides these women with an opportunity to complete their high school education and go to college. Many of the school's teachers and staff are transgender.

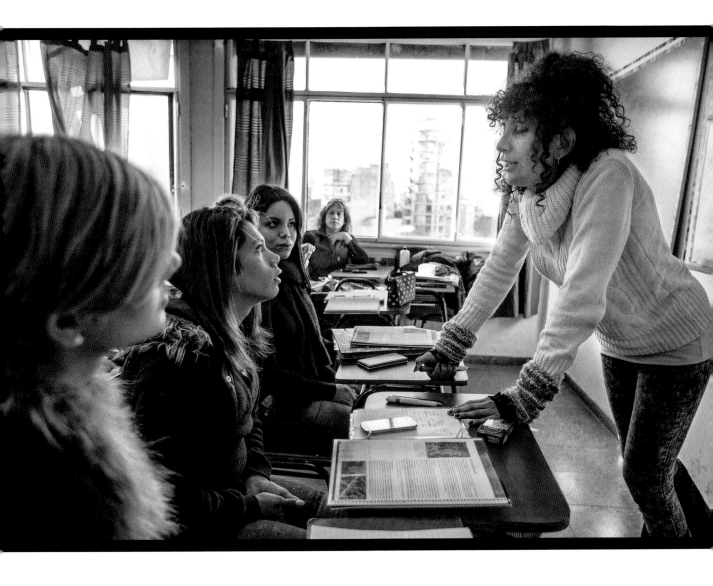

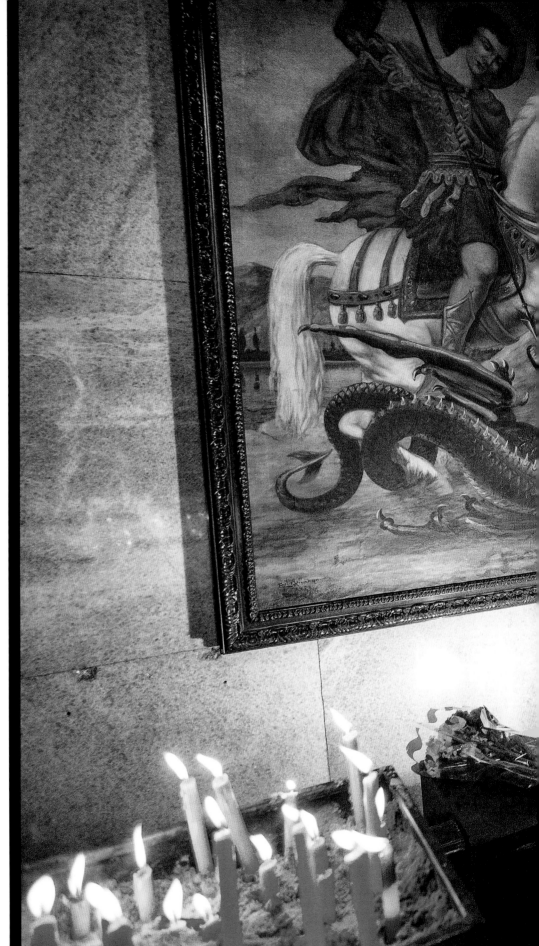

At a Greek Orthodox church near El Gondolín, Valentina Nogales lights candles and prays to Saint George. Valentina feels comfortable here and talks with the local presbyter, who is open to the neighboring transgender community.

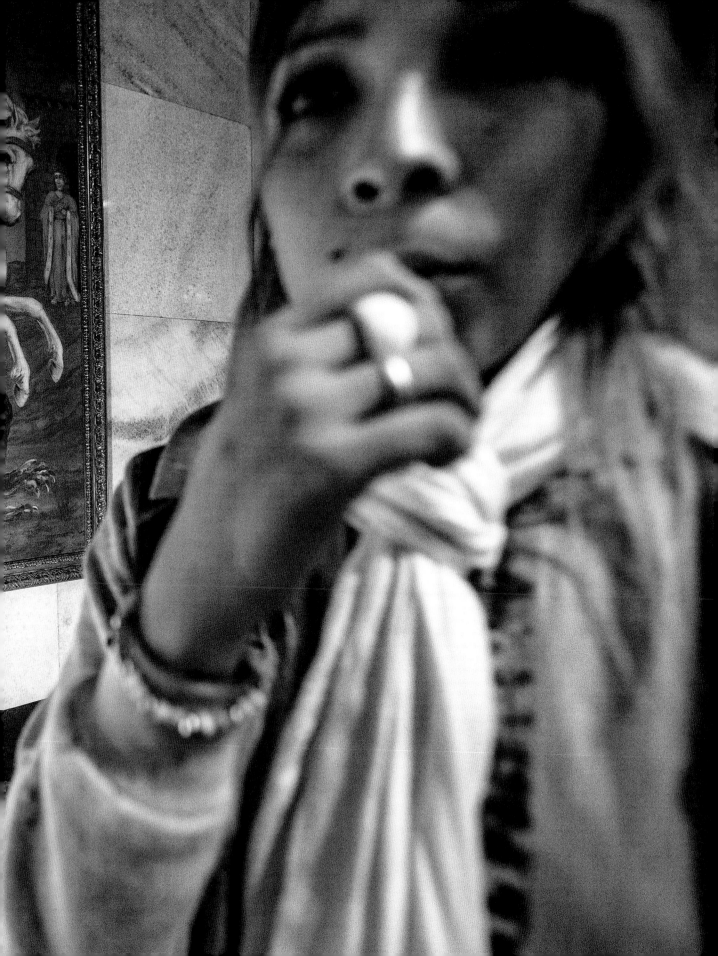

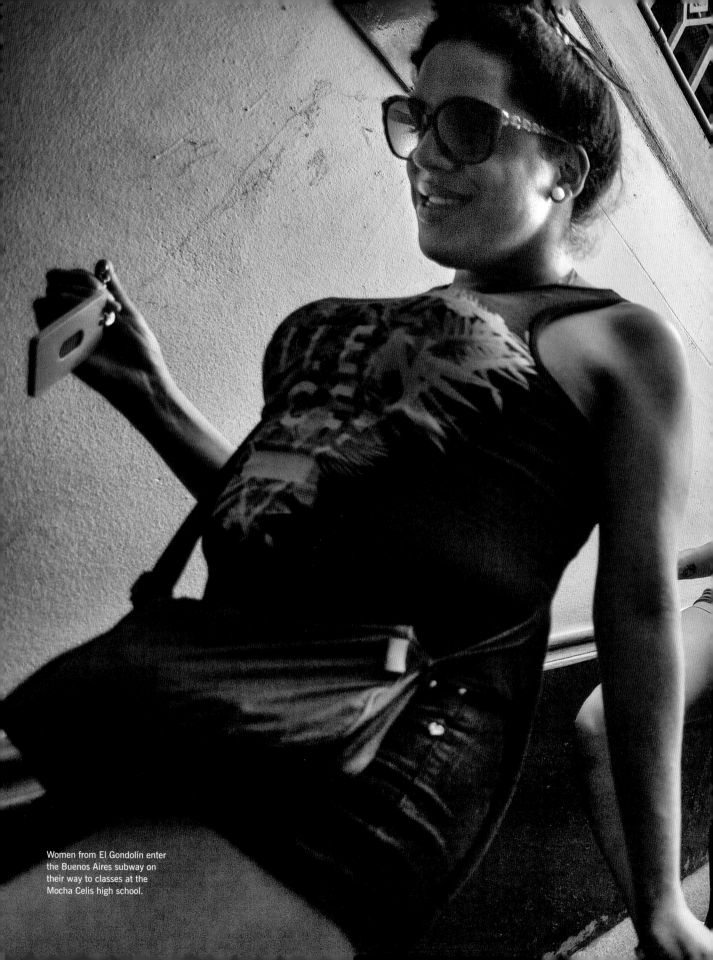

Women from El Gondolín enter the Buenos Aires subway on their way to classes at the Mocha Celis high school.

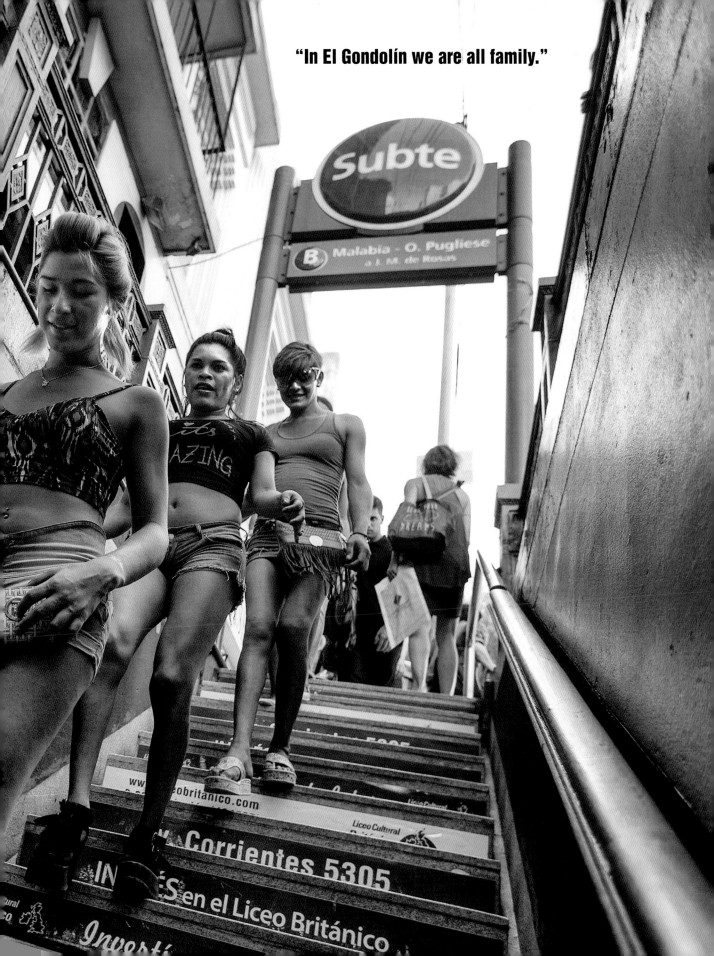

"In El Gondolín we are all family."

Emmanuel
Valentino
Fernandez

A tattoo artist, Emmanuel
has mapped out his own
transformation with his
piercings and tattoos.
Now in a relationship with
Tamara, he is eager to
have a family of his own.

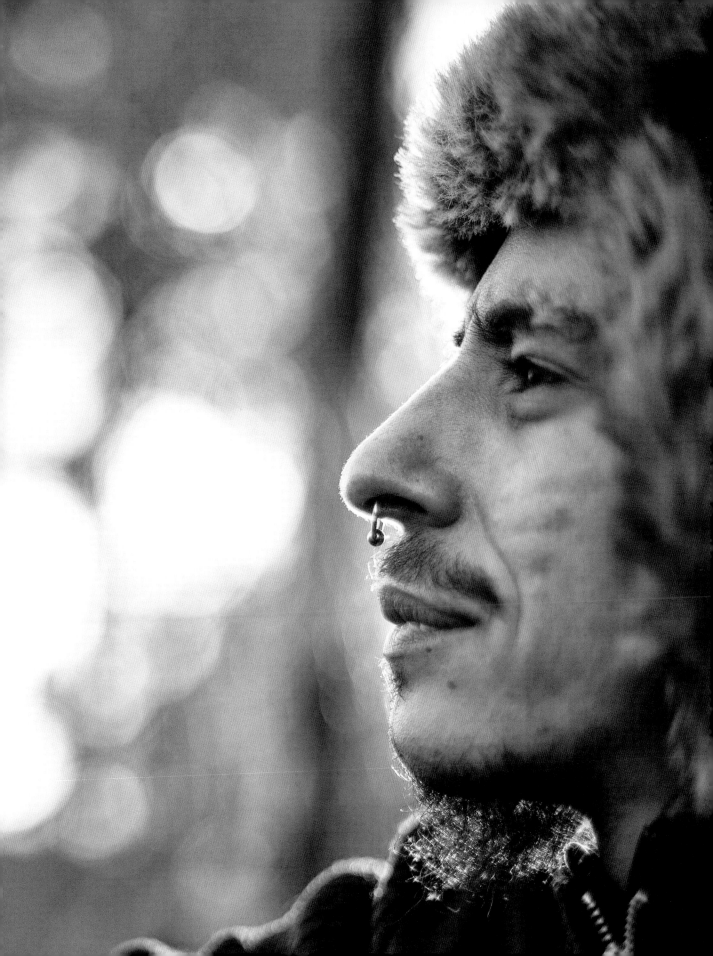

The female name on his identity card was always a burden for Emmanuel Valentino Fernandez, a thirty-nine-year-old transgender man from Buenos Aires. Whenever he had to show his ID, whether cashing a check at the bank or going for a doctor's appointment, the name was a painful reminder of who he didn't want to be.

Although Emmanuel knew very early on that he was different, he only came out of the closet at the relatively late age of thirty. For a long time, Emmanuel had doubted that there were people like him, and he didn't think he could find anyone who would understand his feelings. As so often happens

"In the past, every time when I had to show my identification document, it happened that what the person in front of me saw didn't match my aspect. The official or whoever was there didn't believe it was me. It was a violent act."

with young transgender people in Argentina, he finally connected with others online.

Eventually Emmanuel told his family about his desire to transition. For his beloved grandmother, this wasn't a surprise; she had long suspected. She and his mother both supported his decision—his mother renamed him Emmanuel—but for Emmanuel's father it was a difficult and painful process, and it took a long time before he could embrace his son again.

Emmanuel's body now shows the history of a physical transformation that lasted for years. The tattoos and the piercings testify to a desire to change, which culminated in a mastectomy. Now Emmanuel is a tattoo artist himself, a profession that fits him well. He visits his clients at their homes. He is also studying art at college so that he can become even more skilled at what he loves to do.

When Tamara Ramirez saw a photo of Emmanuel for the first time, she immediately fell for him. Emmanuel and Tamara have been living together for the past three years in Isidro Casanova, a town in Buenos Aires Province. They both dream of having children and enjoying a family—a dream that could have been denied to them only a few years ago.

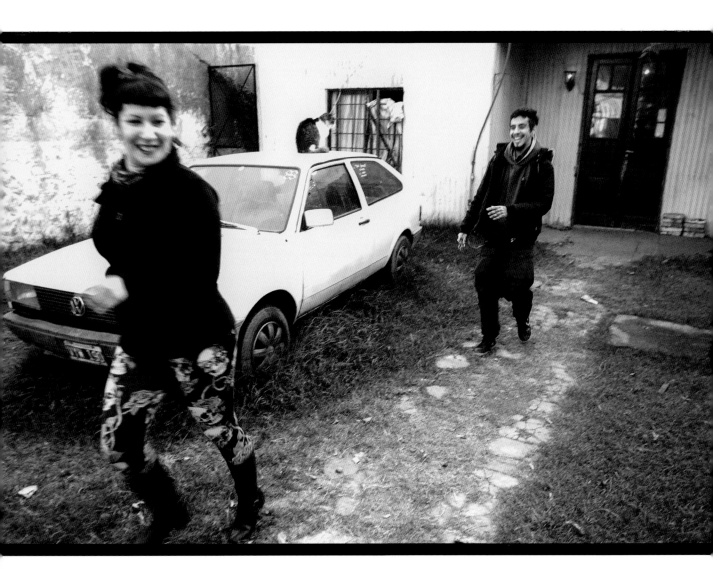

Emmanuel and
Tamara leave their
home in Isidro
Casanova, a suburb
an hour from central
Buenos Aires.

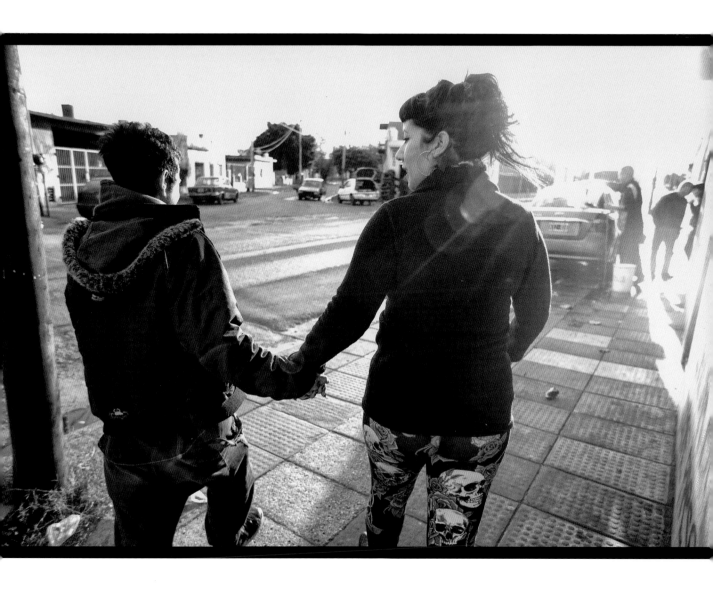

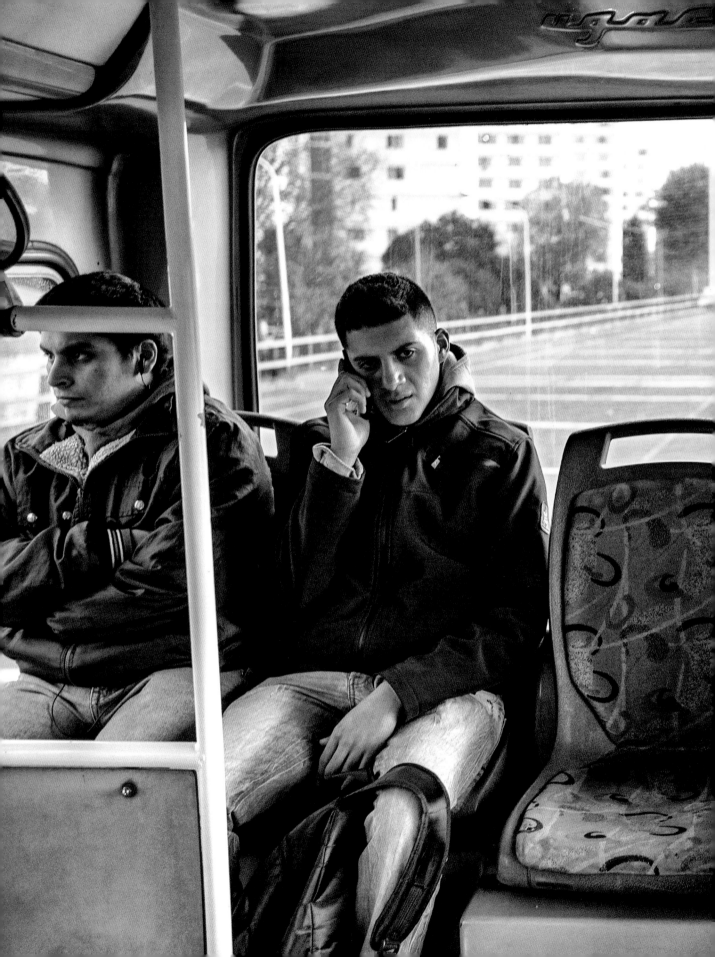

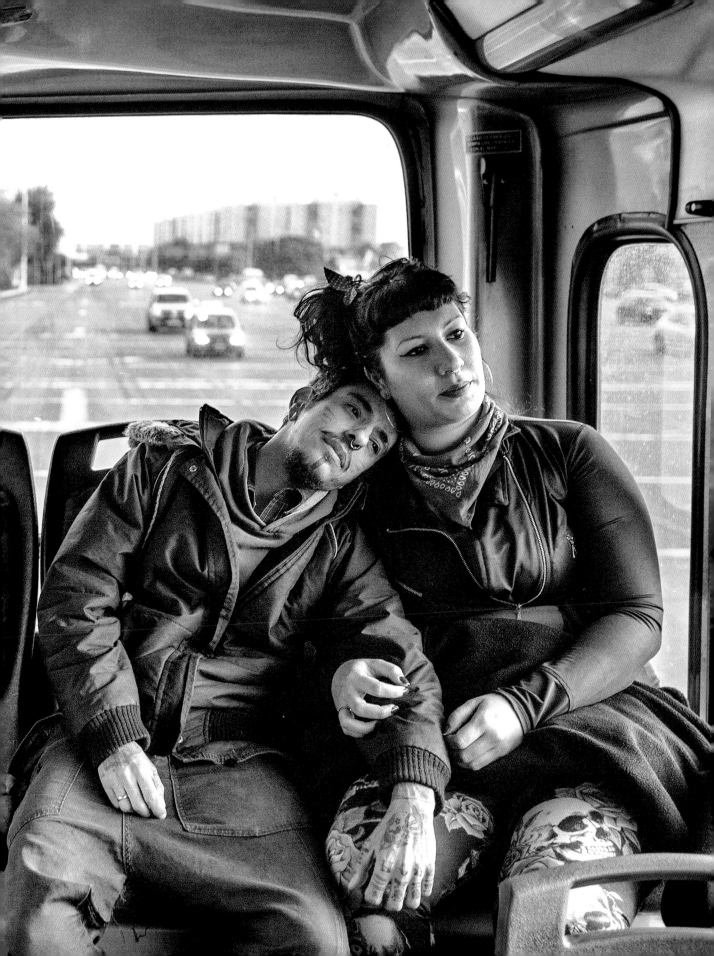

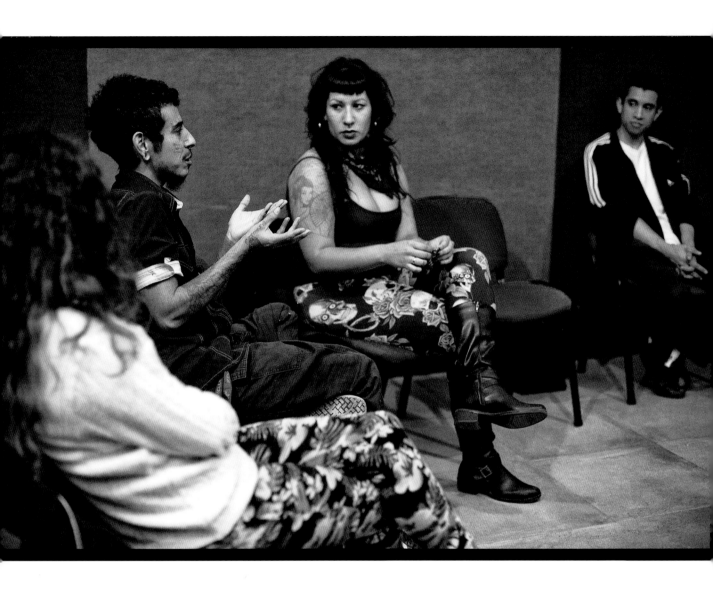

Emmanuel and
Tamara take part in
a discussion after
a film screening in
Buenos Aires.

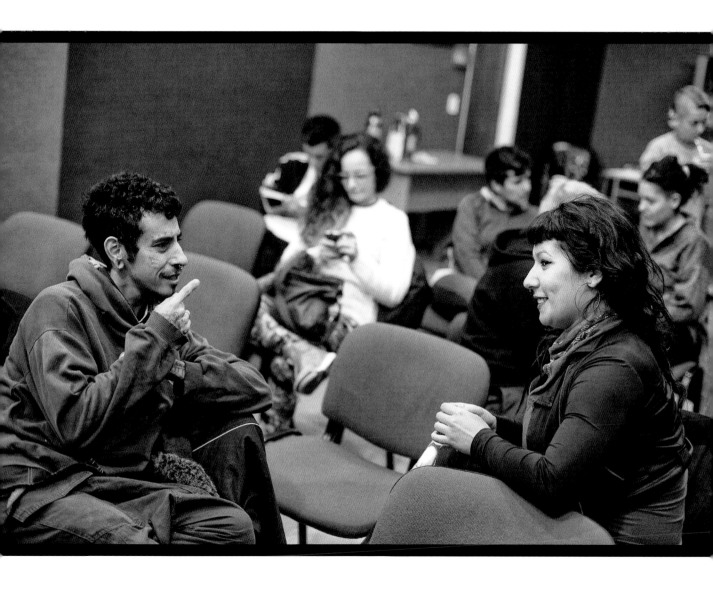

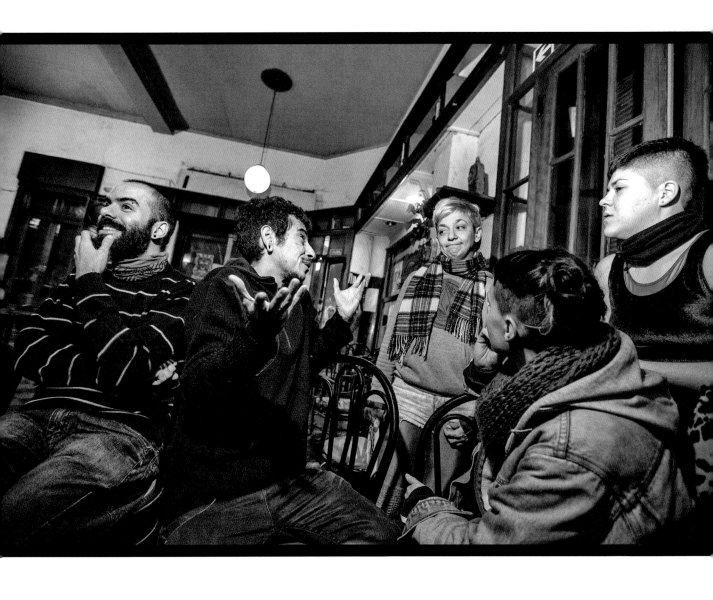

Emmanuel at a bar in
Buenos Aires celebrating
a friend's birthday.

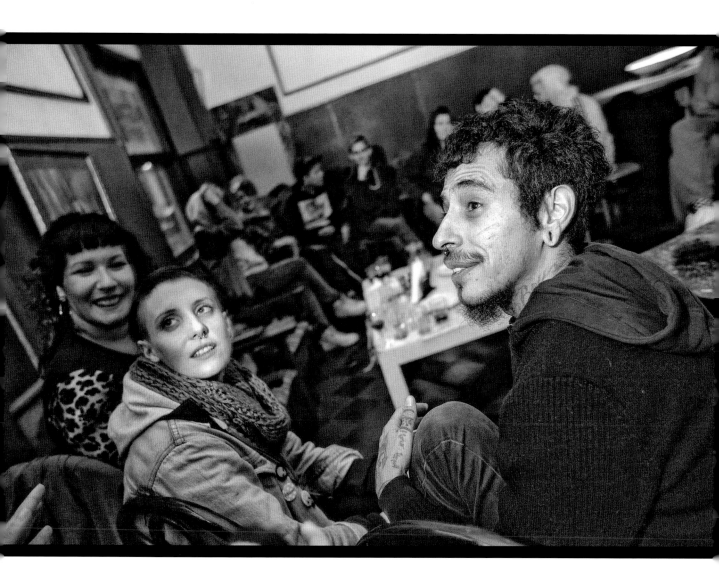

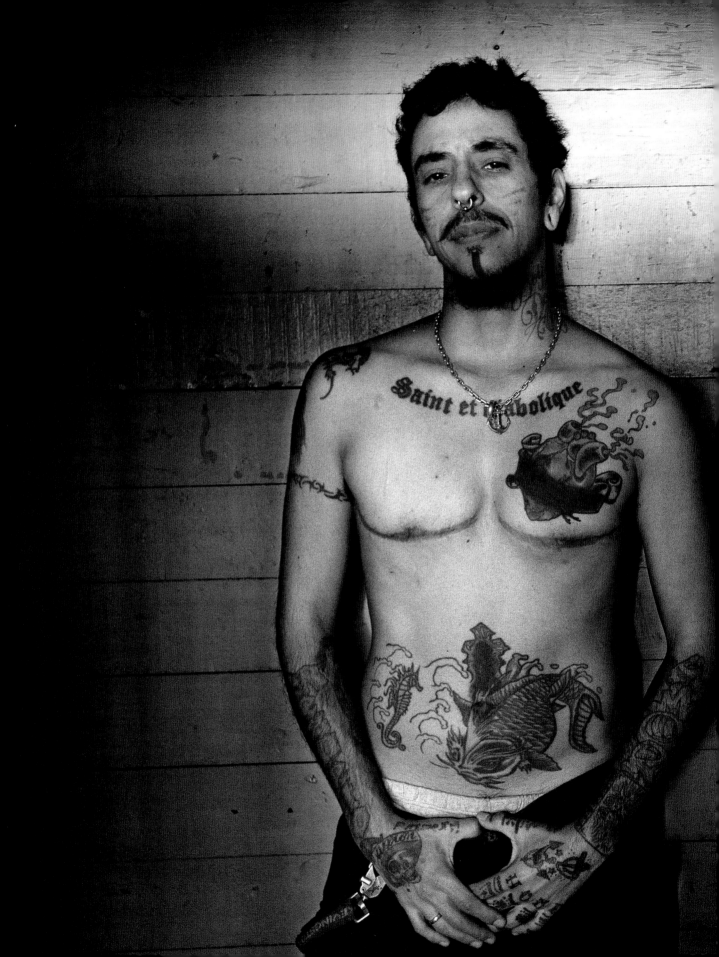

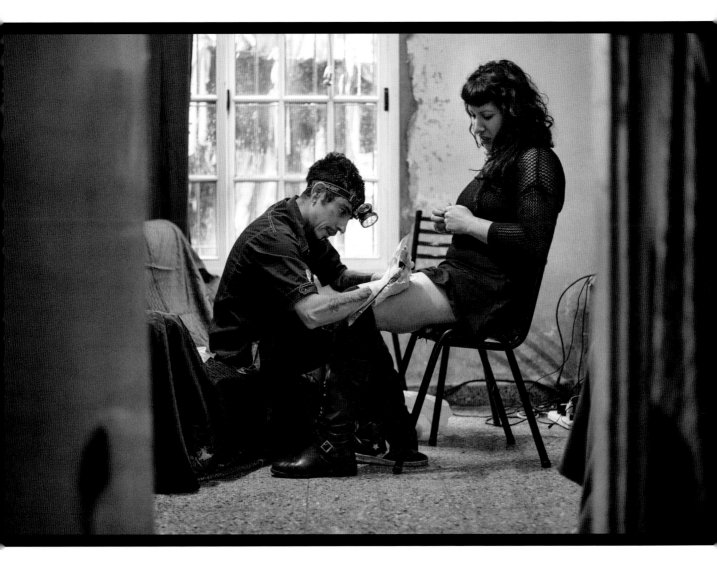

Emmanuel is working
on a long-term tattoo
project on Tamara's body.

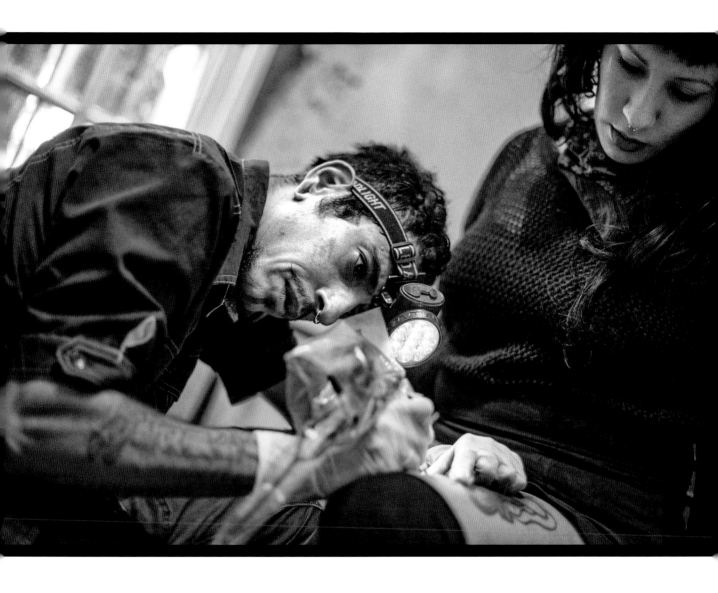

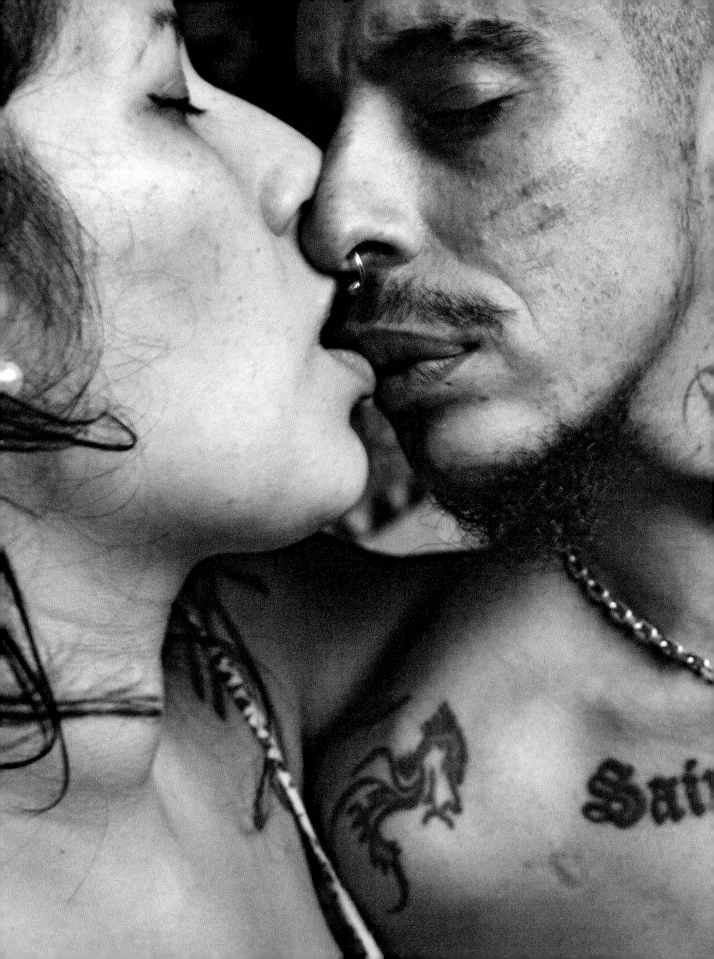

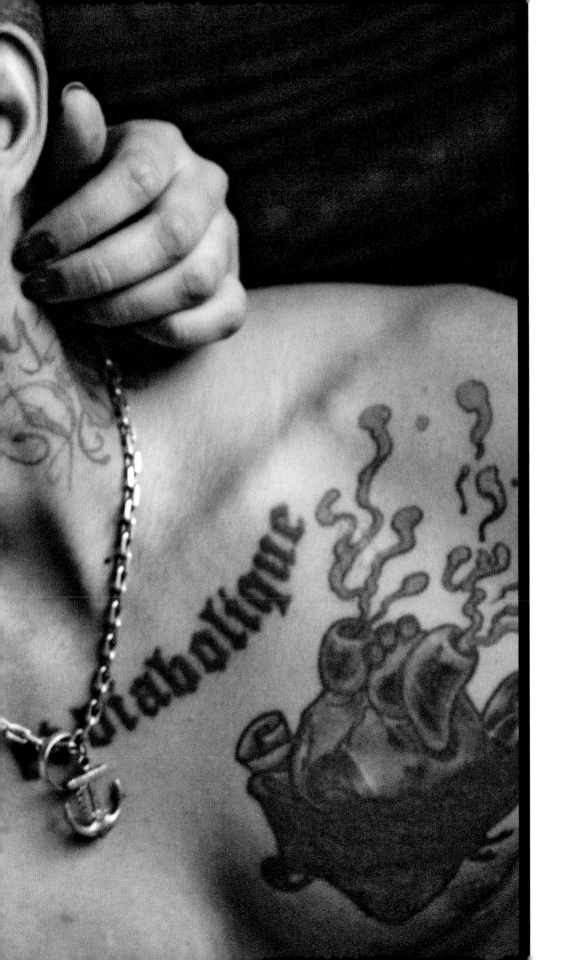

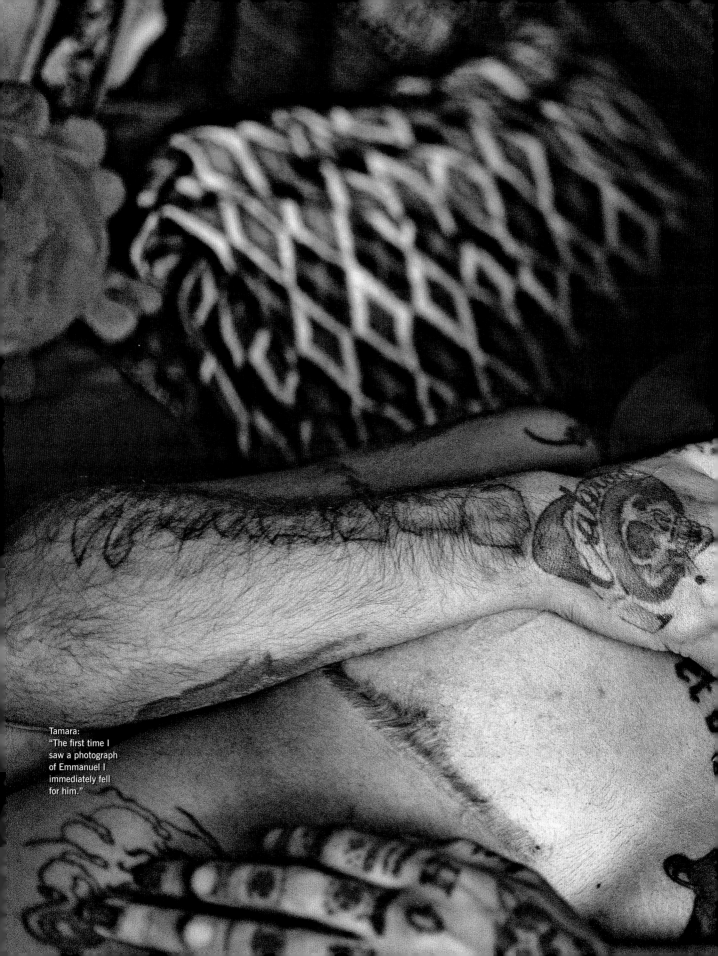

Tamara:
"The first time I
saw a photograph
of Emmanuel I
immediately fell
for him."

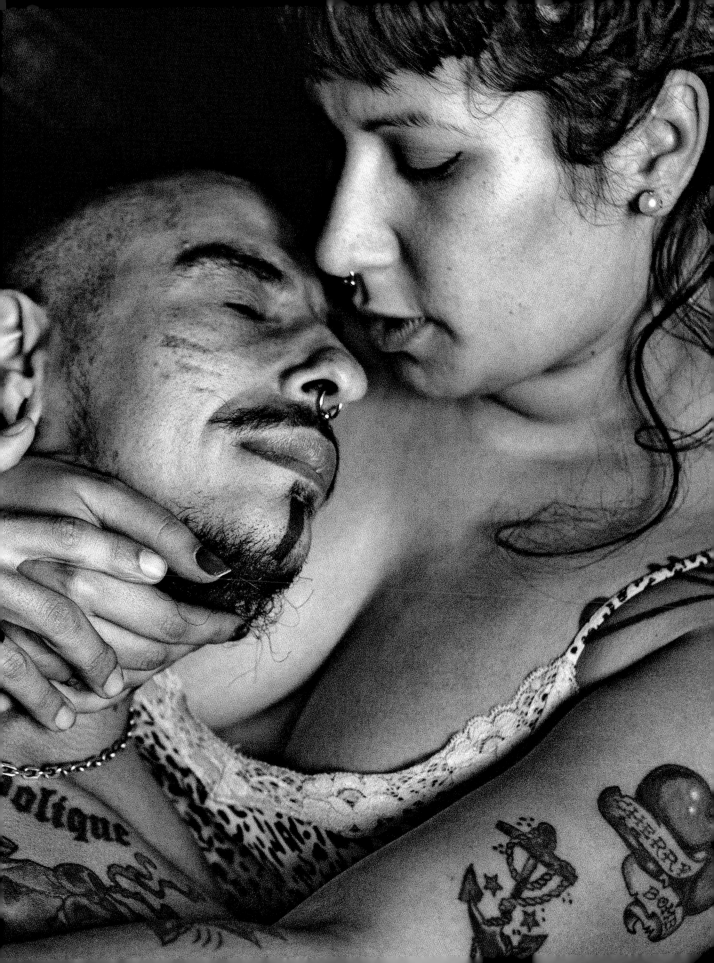

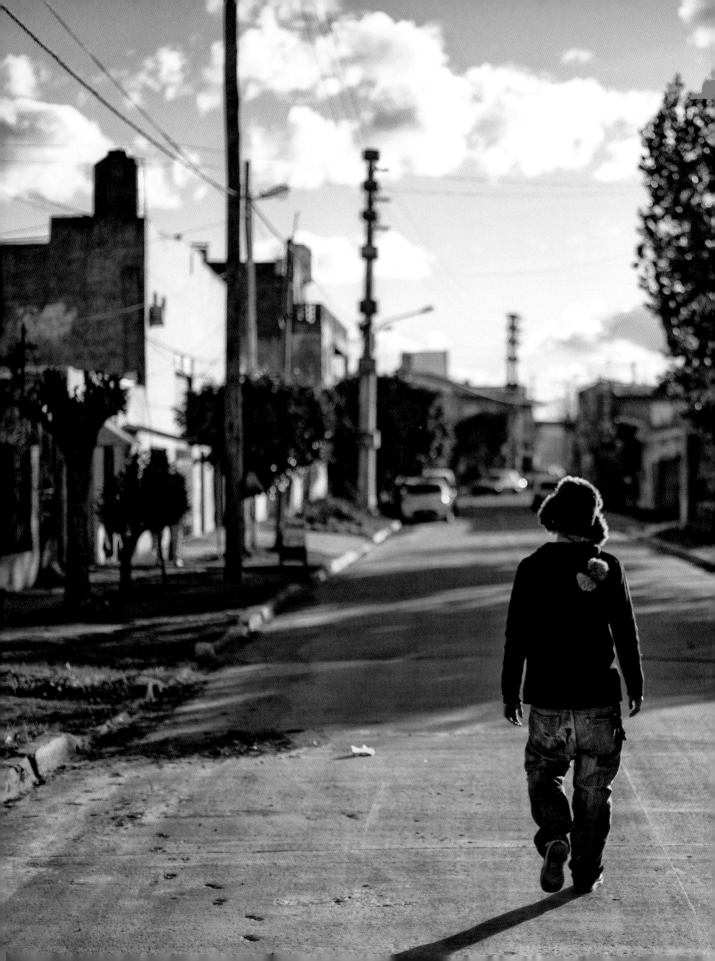

"What I would like in life is to have a family,
to walk along the street with my children,
to be happy."

Serena Sofia Alarcon Rinesi

Tall, blonde, and impeccably dressed, Serena immediately presents a striking figure. Taken to the hospital after a terrible car accident, she was inspired by the care workers there to become a nurse herself.

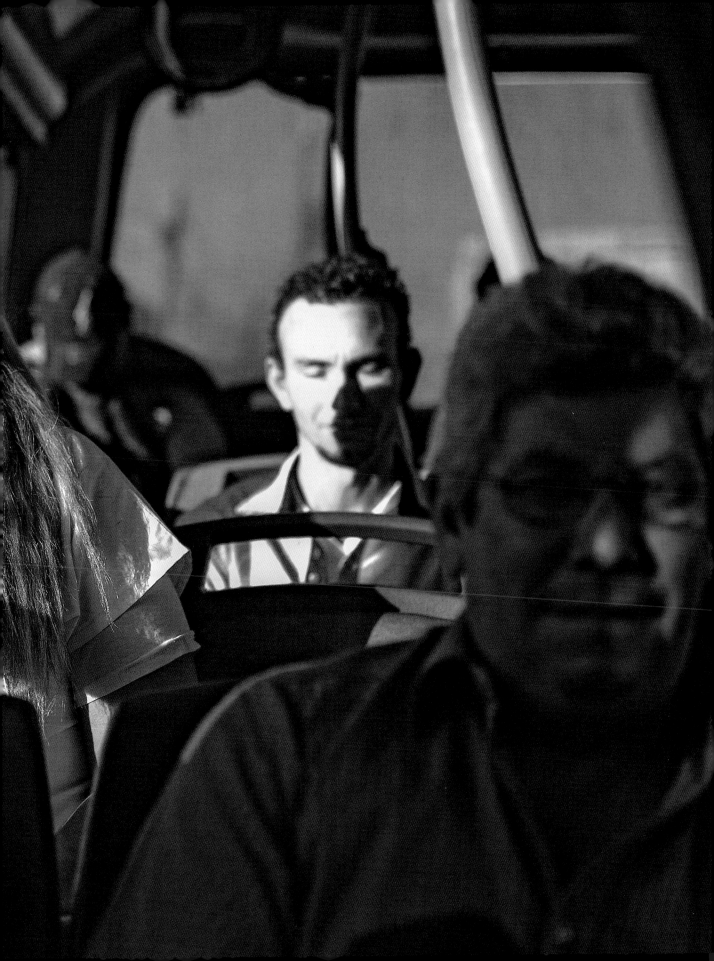

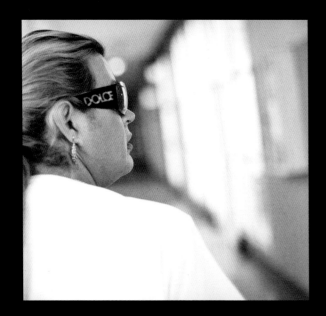

Although Serena thought of herself as feminine when she was a child, it was only at age twenty-five that she decided to transition. The rigid conventions of her conservative town made it extremely difficult for her family to accept her sexual orientation, especially her father, who for a while couldn't make peace with the idea that his own son was a *trava* (a pejorative term for a transgender person). Fortunately, this is now in the past, and Serena and her parents have set aside their differences and developed a close relationship.

Serena moved to Buenos Aires to escape the prejudices of her small town, but in 2008, she met

"I am a nurse and all I ask for is to work as a nurse."

with a dreadful accident. Serena suffered multiple bone fractures in both legs after being hit by a car and underwent several surgeries, spending almost a hundred days in a hospital. While convalescing, she became fascinated by her nurses, who took good care of her, and after she recovered, Serena was inspired to become a nurse herself. She began studying at a Catholic nursing school, and, as Serena proudly recalls, she became the first transgender person to graduate from there.

Since 2012, Serena has been working as a volunteer nurse at the Ramos Mejía Hospital in the working-class neighborhood of Boedo. She has applied several times over the years for a staff position there but so far has not been considered, despite the large size of the hospital and the constant demand for more nurses. Serena attributes this to discrimination. Finally, in June 2017, Serena was offered a part-time job at Trans Vivir, a recently founded sexual health program that targets high-risk populations.

Unlike most transgender people in Argentina, Serena has not legally changed her male name, which she could do if she wanted to under the new Gender Identity Law. She doesn't see herself as a woman, but she believes she is transgender.

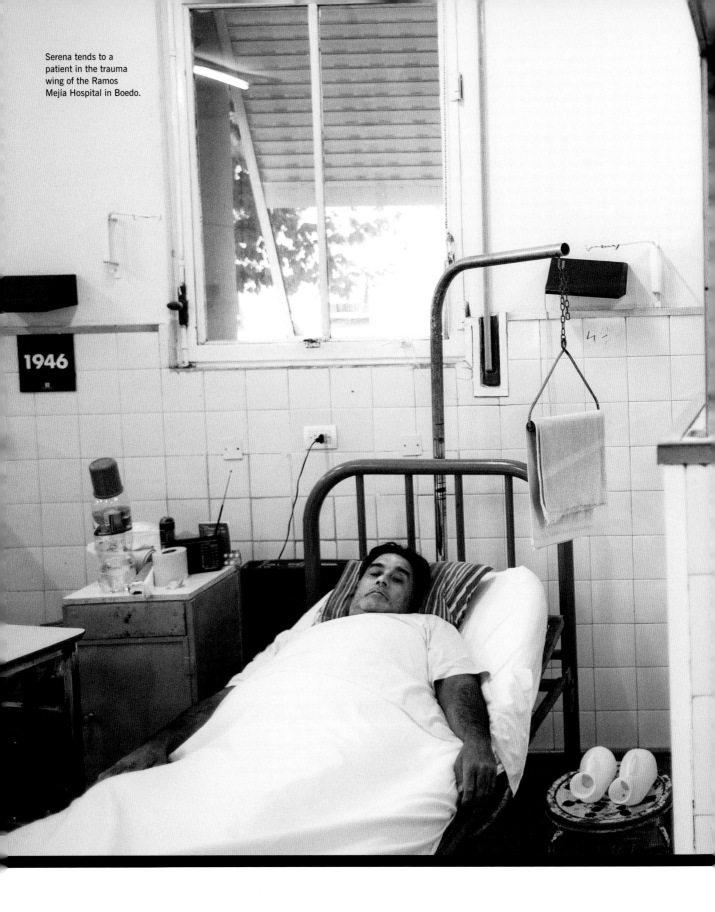

Serena tends to a patient in the trauma wing of the Ramos Mejía Hospital in Boedo.

1946

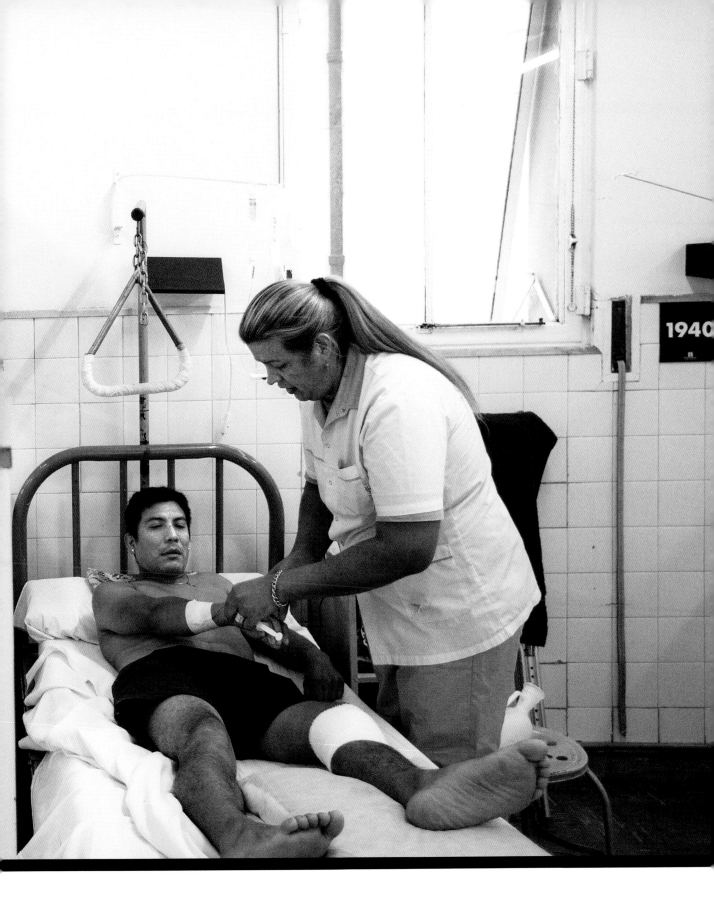

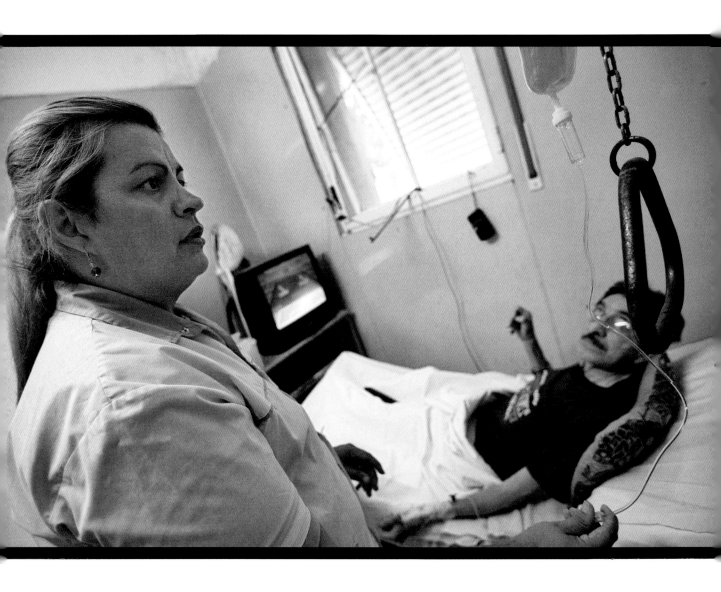

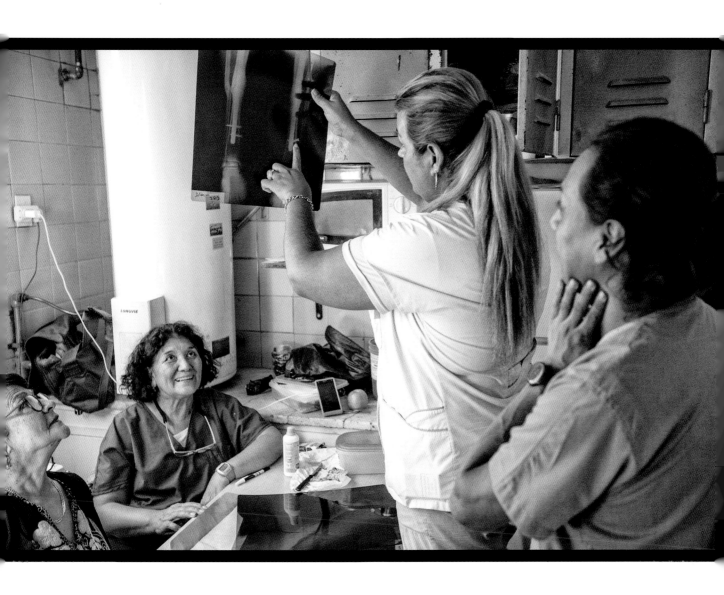

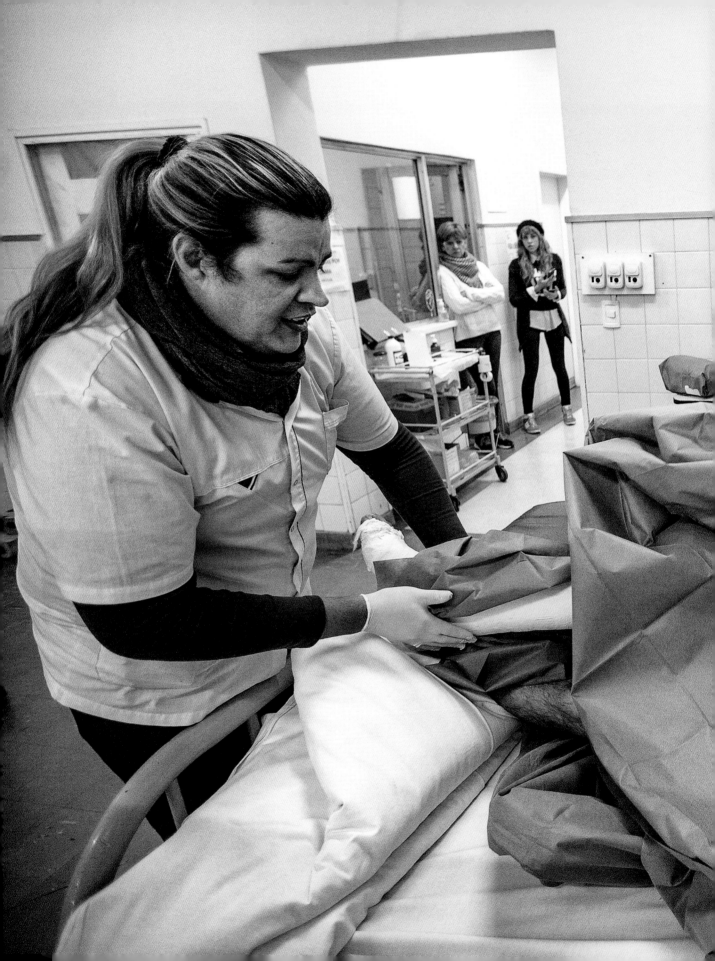

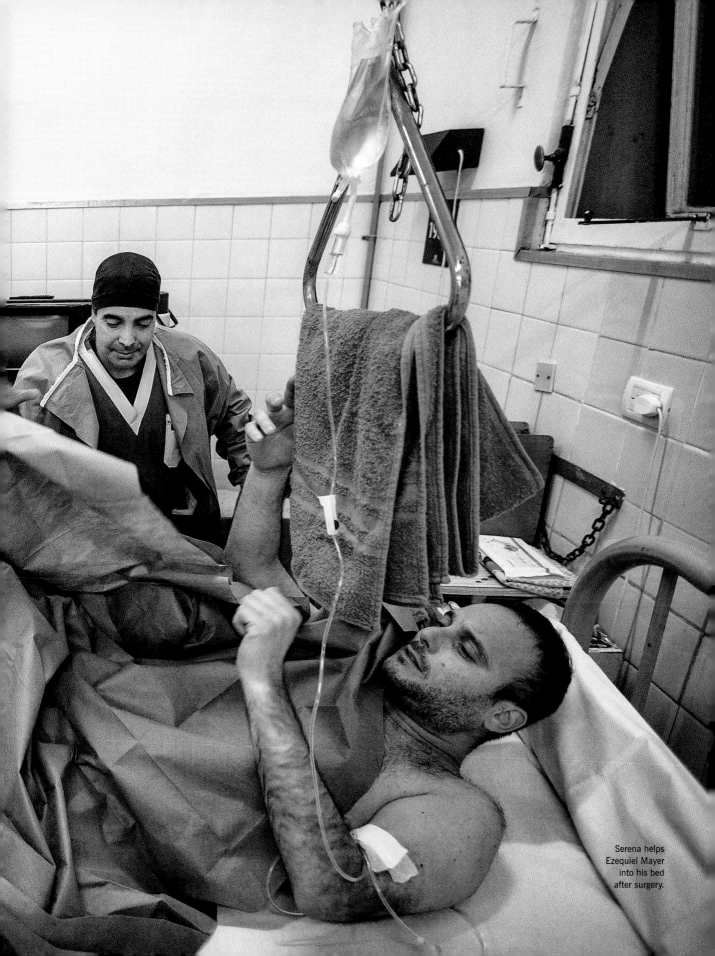

Serena helps
Ezequiel Mayer
into his bed
after surgery.

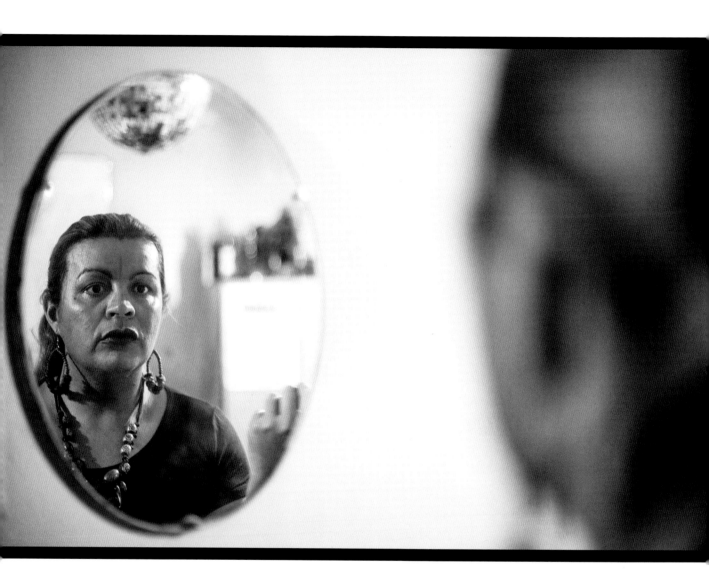

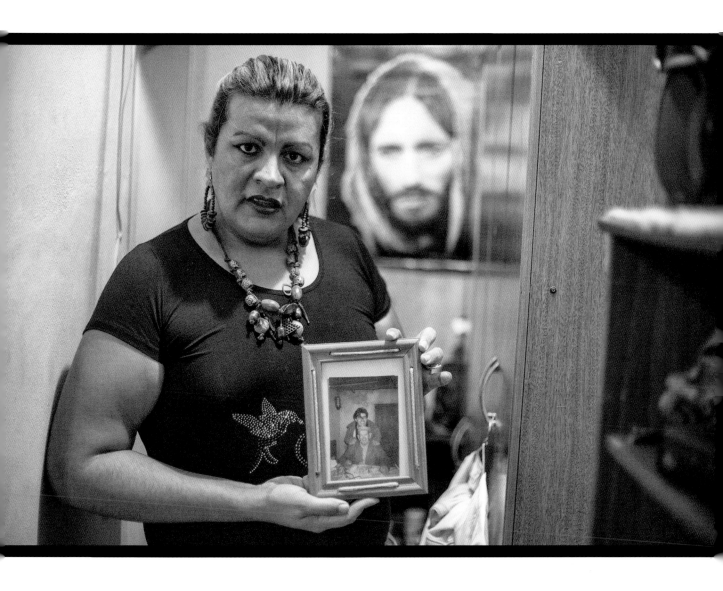

Serena holds an old portrait of herself as a young man with her grandfather.

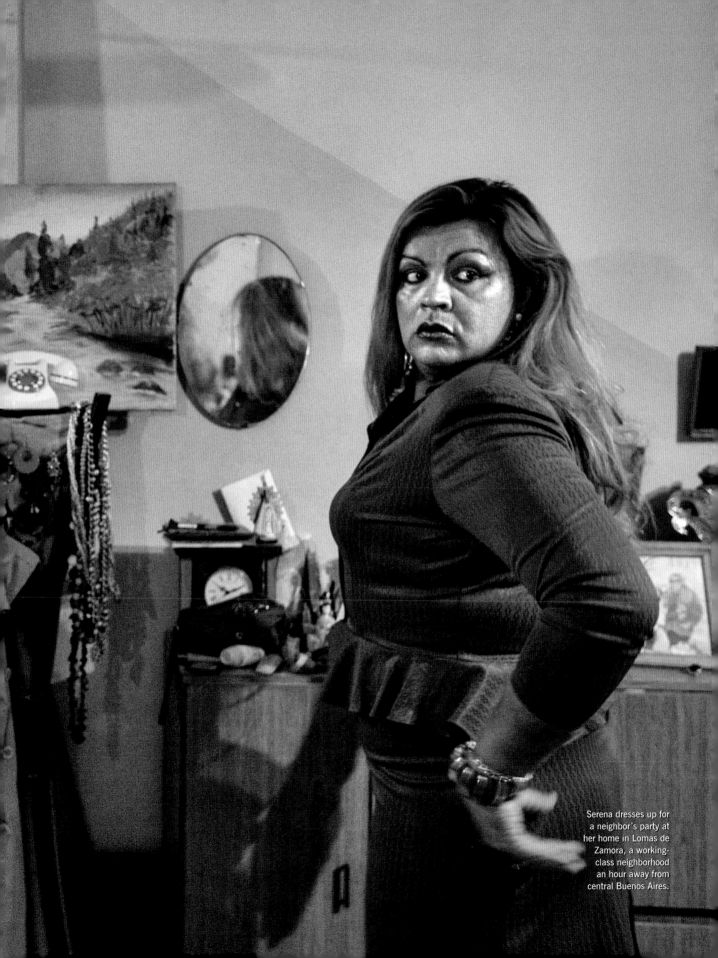

Serena dresses up for a neighbor's party at her home in Lomas de Zamora, a working-class neighborhood an hour away from central Buenos Aires.

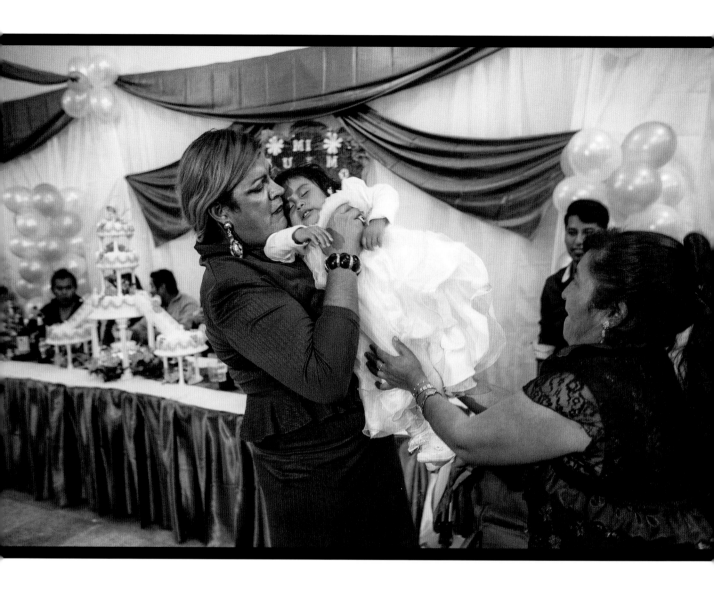

The tallest person
at the party, Serena
celebrates the baptism
of Ailin Torres Garcia,
the daughter of her
Bolivian neighbors.

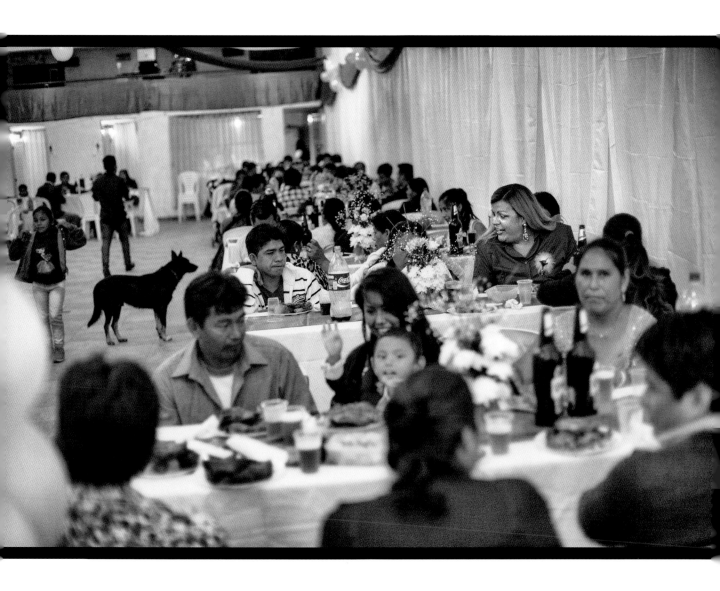

Serena stands at the entrance to the ballroom with her friend Miguel Angel, waiting for the guests to arrive at her birthday party.

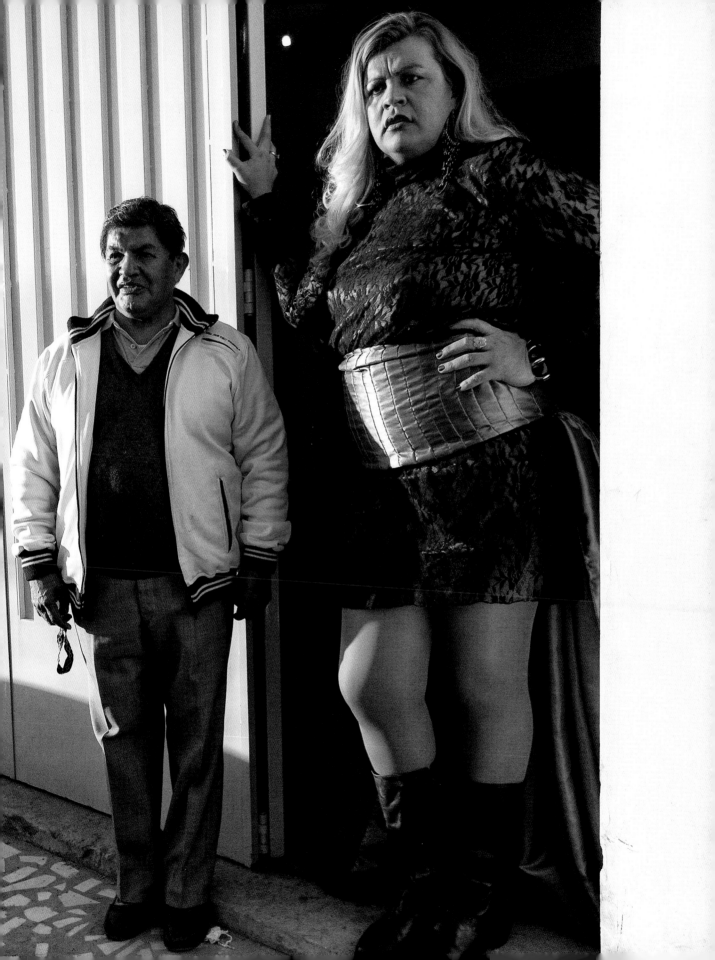

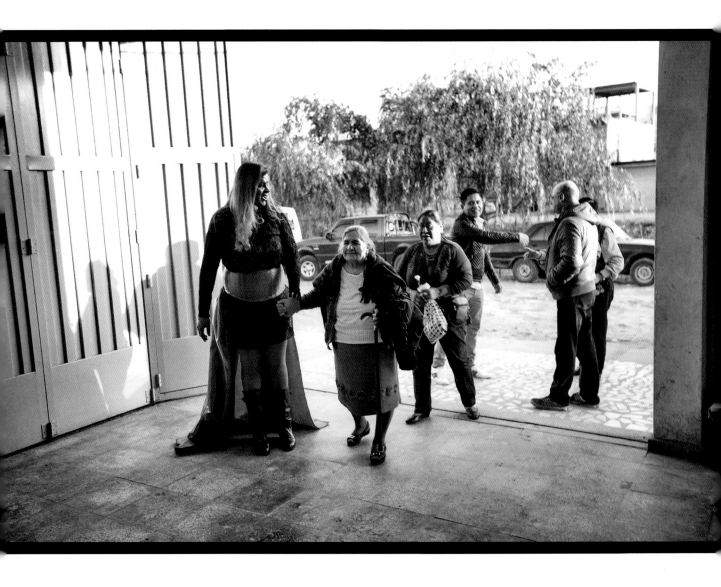

Serena welcomes
her guests.

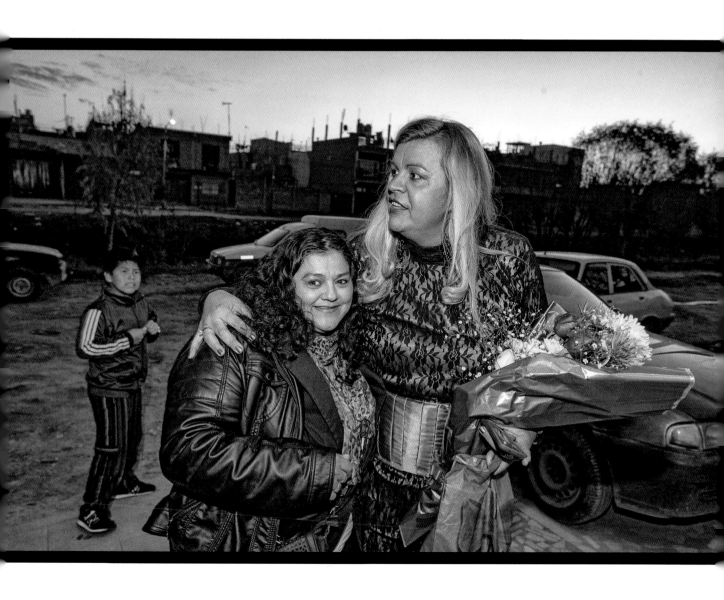

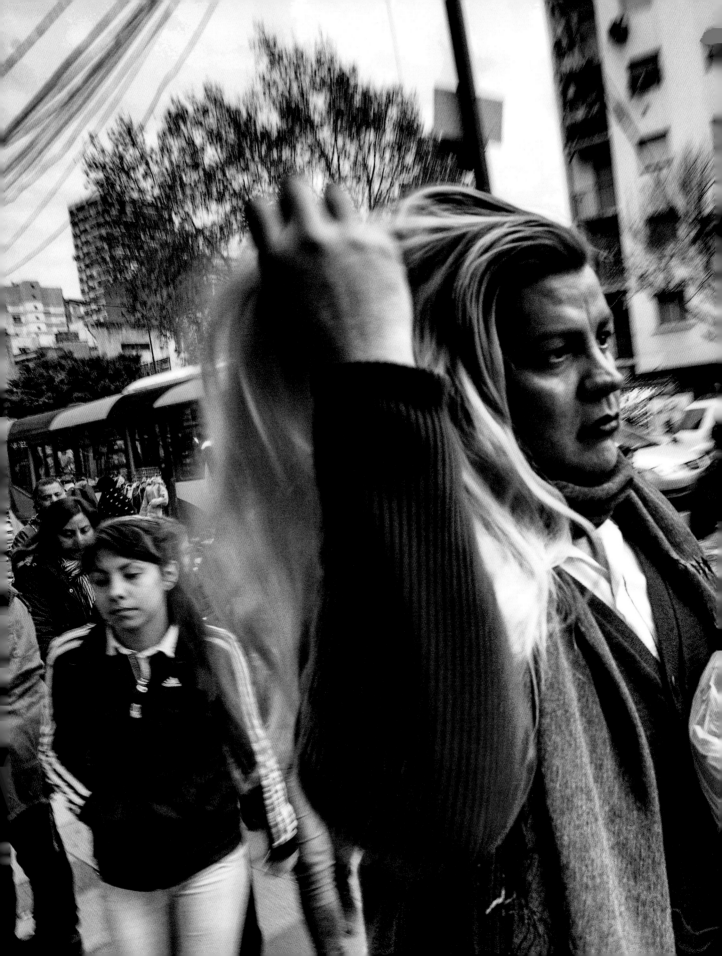

"If I were born again, it would be as exactly the same person. I would not change anything at all."

Acknowledgments

The photographs presented in this book were made possible by Jon Stryker: philanthropist, architect, and photography devotee.

This book was made possible in part by a grant from the arcus FOUNDATION*

I would like to thank everyone who, in one way or another, helped to gather the moments captured in this book. As with most of my work, without the generosity of friends and activists, this book would have never been completed.

To my dearest Marie Gamondes, with thanks for the extraordinary solidarity during the weeks I stayed at her cozy home in Boedo.

Many people in Argentina and the United States helped me during different stages in the production of this book. Thanks to Florencia Rausch, Sebastian Naidoo, Santiago Verzi, Sensi Quintero, Ricardo Gamondes, Ana Luque, Alejandro Gonzalez Medina, Rafael Vicente Fernandez, Connie and Daniela Comaleras, Germán Freire, Laura Martinez, Alejandro Reig, and Juan Pablo Queiroz for generously sharing their ideas and their contacts. Their contributions were essential throughout.

Thanks to Robin Savinar and Tarek Milleron for editing my texts in English.

Many thanks to Josefina Fernandez. Josefina not only wrote a thoughtful introduction to the book, but, of critical importance, she opened the doors to the transgender community in Buenos Aires.

Thanks to Florencia Miranda, Valentina Nogales, Zoe Lopez, Marisa Acevedo, and the people of El Gondolín, who initially didn't know exactly what I was doing there but nevertheless allowed me in so that I could tell others about their lives.

I am thankful to Francisco Quiñones Cuartas, Miguel Nicolini, Lucia Romina Escobar, and the students from Bachillerato Mocha Celis, who allowed me to take pictures of this revolutionary institution.

My deepest gratitude to the amazing protagonists of this book: Florencia and Alejandro, Emmanuel and Tamara, Cinthia and Serena, and the women from El Gondolín. I believe your bravery will empower generations of people to choose the lives they want to live.

I am indebted to Jurek Wajdowicz, Lisa LaRochelle, Emma Zakarevicius, and the EWS Design team. Jurek not only believed early in this project, but he was always willing to discuss ideas and perspectives throughout the process.

Thanks to Ben Woodward, Emily Albarillo, Fran Forte, Andrea Smith, and The New Press team for their commitment. Thanks, too, to Kevin Dunn for his sensitive translation of Josefina's introduction.

Thanks to Jon Stryker and the Arcus Foundation for continuing to support my work.

Much credit goes to my parents, Radames and Alicia. They fed me with an unconventional mix of values I believe to be indispensable to my photography.

Last but not least, I am deeply grateful and indebted to Clementina and Mora for their unconditional support. My work is dedicated to them.

*The Arcus Foundation is a global foundation dedicated to the idea that people can live in harmony with one another and the natural world. The Foundation works to advance respect for diversity among peoples and in nature (www.ArcusFoundation.org).